Enjoy y'all... judi goolsby

Y'all

...painted memories of the South

judi goolsby

First Printing, 2015

ISBN-13:978-0-692-45208-0
Library of Congress Control Number: 2015906657

www.judigoolsbyart.com

Book Layout by Alchemy Marketing Inc.
www.alchemymarketinginc.com

ultimate thank you
jpg

7

Dedication

To: Bobbie Jean McRoberts East Gregory
Who showed me that LIFE is the story.

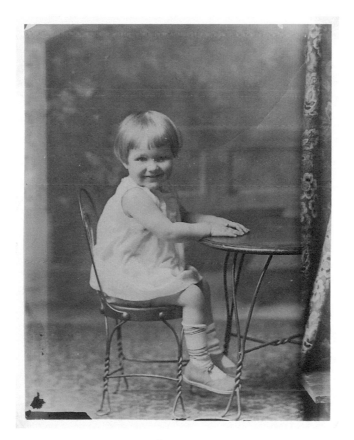

Mother
Bobbie Jean McRoberts, 1928
Age 3

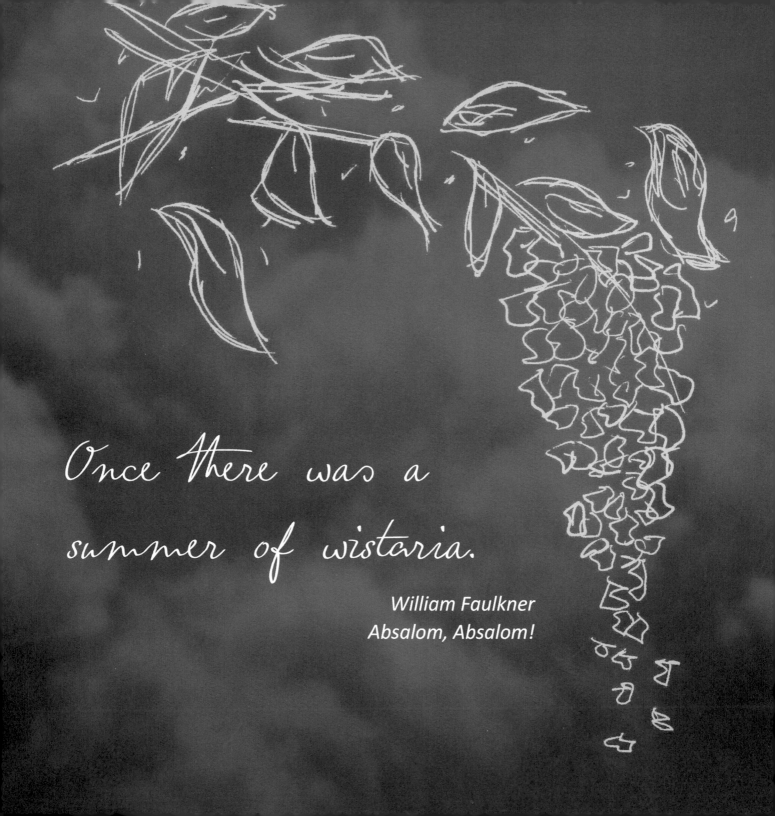

Once there was a summer of wistaria.

William Faulkner
Absalom, Absalom!

Y'all

If Faulkner meant *wisteria*, the saturated sweet smell of purple clusters hanging heavy from woody vines, I can relate.

It's hollyhocks, fuchsia azaleas, snapdragons, heliotrope, peonies the size of china saucers, perfume like gardenias, honeysuckle, magnolias and kudzu engulfing everything in its path.

If he meant *hysteria*, I can absolutely relate to that too.

Swimming in creeks in the Louisiana bayous with moss hanging low over the banks and watching for water moccasins' white mouths along the edge, I relate to that.

A close call but no fingers lost on the 4th of July when stuffing firecrackers in a tomato can and lighting them with matches.

I remember a twinge in my stomach and looking up at my Pampaw when I passed drinking fountains with signs on the wall that read COLORED and WHITE.

Looking for the small child's casket resting high in a bare tree guarded by a snake.

Yep. I can relate to it all.

I was there.

I was a child of the South in the 1950s.

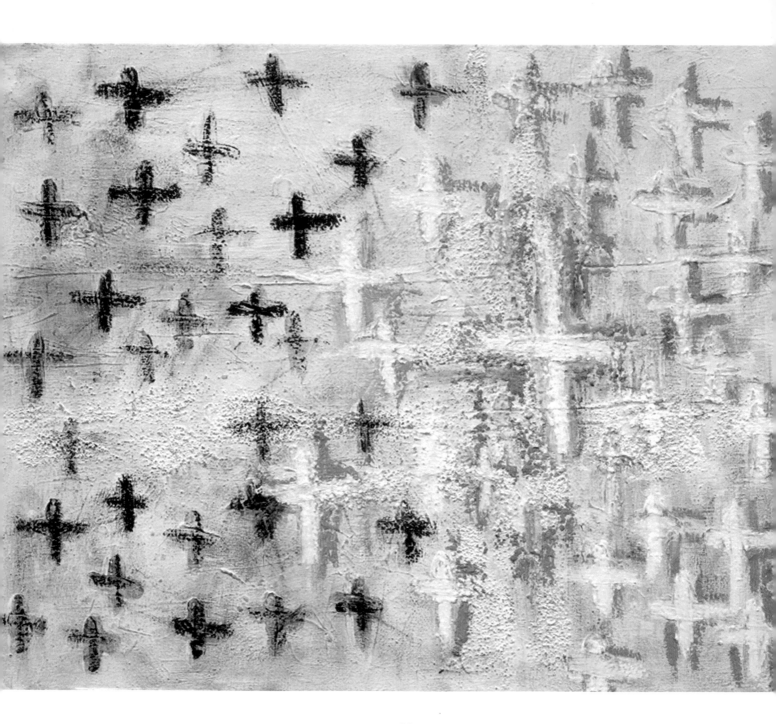

August 14, 1945

I began this painting on an overcast day, which was unusual for Santa Fe. Whether it is cold or hot, it is almost always sunny. As usual, I brushed on layers of colors, hosed some off, and put more on. I painted August 14, 1945 in large letters on one of the early layers. I knew the date would eventually be covered up, but I would always know it was there. I pressed sand onto the surface of the wet canvas. This seemed appropriate, because the painting was about the end of the war in the Pacific and my father's death on the island of Okinawa, Japan.

This painting was very difficult. I worked on it off and on for weeks, putting it aside while I worked on other paintings, and then trying again. I changed parts of it and added new colors. I changed the colors of the crosses so many times that the canvas became heavy with paint.

Why was this painting such a struggle? Was I trying to find a balance of life and death, despair and hope, tears and joy? I needed this painting to tell a story of the war where my father and others willingly gave their lives. I found that their principles of duty and commitment to protect family and country were difficult to render with paint and canvas. So I went back to the painting over and over again.

In the end, the colors on the brush took on a life of their own and brought me to a place where I felt I could stop and breathe.

My father was 22 years old when he died on May 28, 1945.
The war in the Pacific ended on August 14, 1945.
My mother was 20 years old when he died. I was 17 months old.

I've often thought, how would my life have been different if the war had ended 3 months sooner?

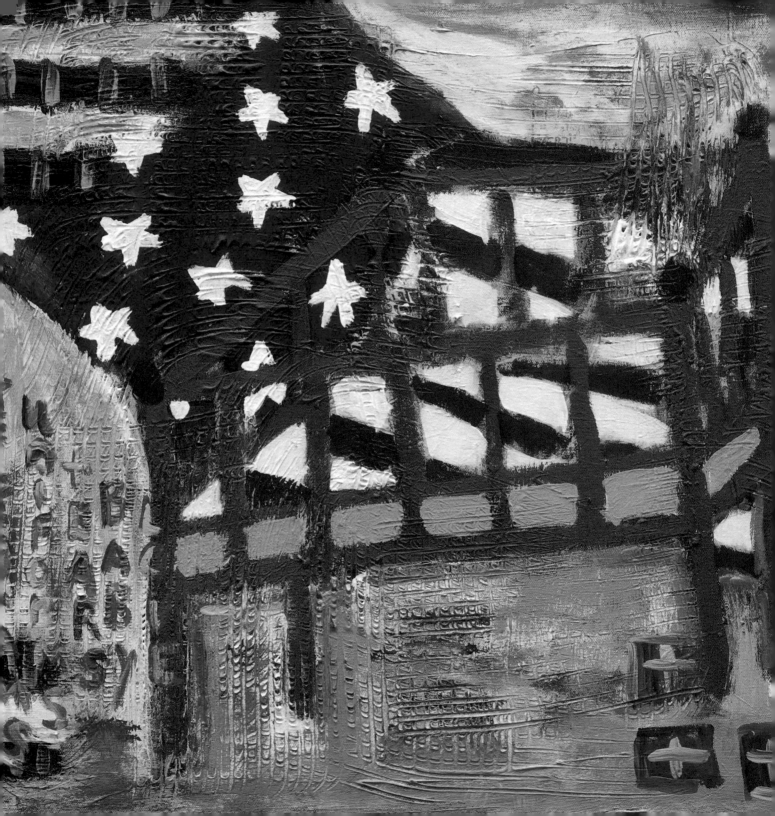

When Word Came

It was May 1945. My mother and I were living with my grandparents in Louisville, Kentucky while my father was overseas in the Navy. Families often did that during World War II. Times were hard, and everyone did their part. Gas and many needed materials were rationed, and women's stockings were a luxury. People worked in factories that had been refitted to help the war effort. My grandmother was *Rosie the Riveter*, working long hours every day in a munitions factory.

In the front window of our modest brick house was a small red, white, and blue banner with gold tassels and a white star. If you walked down any street in any neighborhood in the United States, you would see these banners. White stars were for those actively serving, while gold stars were for those who had been killed.

Early one morning, a young man rode up the sidewalk, stopped at our house, and got off his bicycle. He walked up the steps to the front door. I was asleep in my crib when my mother opened the door.

"Mrs. East?"

She reluctantly took the unassuming yellow envelope from his hand. She already knew. Of course she knew. But she made herself read the return address on the corner: War Department, United States of America, Department of the Navy.

As my mother slowly sank to her knees the young man lowered his head. "I am so sorry," he said.

She was now a widow at 20 with a 17-month-old baby. The white star on the banner in the window would soon be replaced with a gold one.

It is still hard for me to comprehend the impact of that simple yellow envelope. She was so young and strong. She told me later that while she lay beside me on the bed that afternoon, she promised to make the best life for me that she could, no matter what it took, and she kept that promise.

The aftershocks of this story rippled through my entire family for years, even now shaping so much of everyone's identity, especially my own.

I have the yellow telegram and the Purple Heart engraved with my father's name—Aubrey Leonard East. I also have the folded flag the Navy gave to my mother, and boxes of pictures of my father, forever a boy in a U.S. Navy uniform.

These pieces of a too-short life will now go to my granddaughter, born in 2005 in Japan where her father, an F18 pilot, served in the Navy. They named her Aubrey.

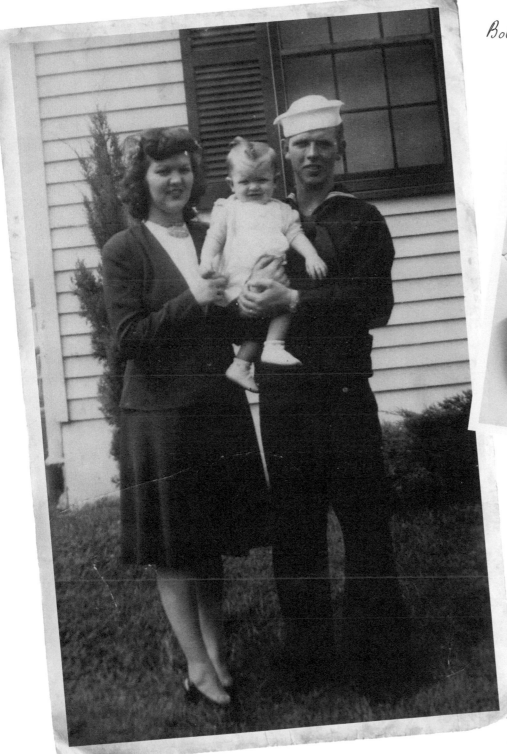

Bobbie Jean and Aubrey East
and Me
1944

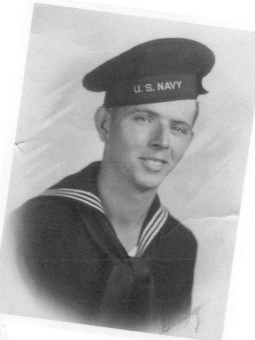

Aubrey Leonard East
EM3c USNR

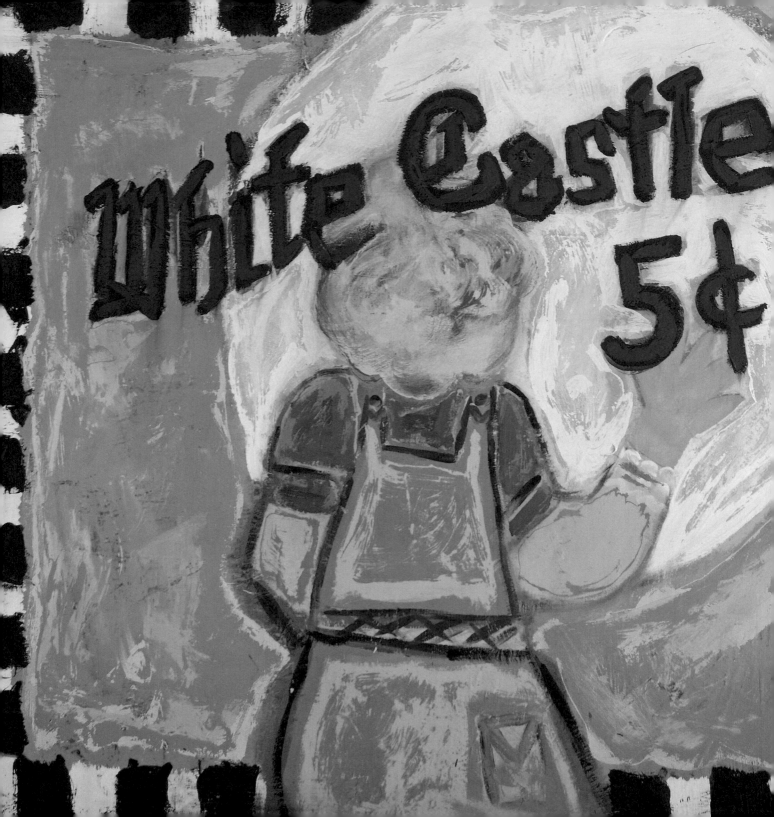

White Castle

My mother worked full time after my father's death. Since we were living with Memaw and Granddad McRoberts, Memaw took care of me during the day. I was three years old, a curly-headed blonde with blue eyes and a healthy amount of independence and energy.

I loved Granddad dearly, and every minute spent with him was like a gift. He was tall and strong with wire-rimmed glasses. Later, when I saw pictures of General Dwight Eisenhower, I thought he reminded me of Granddad. I wanted to please him, and whenever he made an offer that included food, I paid close attention.

Granddad worked nights at DuPont Chemical in post-war Louisville, Kentucky. Shift work was tough. It was difficult to keep a three-year-old quiet while Granddad slept during the day. But I was motivated. If I was quiet and didn't bother him, he would sometimes take me to White Castle for hamburgers when he woke up.

Memaw knew how to keep me out of trouble and occupied with things that she and I both loved. She read to me. We planted flowers, colored with Crayola crayons in coloring books, and best of all, strung buttons.

Most of the buttons were kept in a metal fruitcake tin. (I later decided that the empty tin was the best part about fruitcake.) The many shapes and sizes and colors of the buttons looked like candy. Memaw taught me to string buttons for bracelets and necklaces. She taught me how to sew a button on a piece of cloth. One of my favorite things to do with the buttons was to make a figure with arms and legs. We called him "The Button Man."

On the days we went to White Castle, Granddad held my hand as we walked through the neighborhood

full of trees. The modest red brick and frame houses all had porches. Many of the porches were painted white and filled with giant ferns on tables or hanging from chains. One owner brought his caged bird outside, where it could sing with its relatives in the trees. In those days people sat on the porches and visited with friends and neighbors.

Miss Lilly's little black-and-white dog, Charlie, always barked as we walked by. As soon as we stopped moving, however, he wagged his tail and ran to us for a pat on his head.

Walking along, we heard the click of push mowers and the smell of cut grass filled our noses. Sprinklers lapped over the edges of lawns, and as the water soaked the warm concrete an unforgettable scent filled the air. It was the kind of smell that would bring back the memory of summer every time I get a whiff of wet pavement.

We had to cross Bardstown Road, a busy street, and Granddad always let me look and tell him when we could go. It made me feel big. As soon as we crossed the road, I could see the top of the White Castle. It really did look like a castle on top. Opening the door to the "castle" seemed magical. Even more magical was the voice of the man behind the counter dressed in white and blue.

"Hello there, Miss Judi. I have your hamburger right here."

He always seemed to know when we were coming.

I stood on tiptoes and reached up, pushing my nickel across the smooth, white counter. Sometimes we stayed there and ate, but usually we retraced our steps, carrying our sacks of warm hamburgers, tempted by the aroma of onions all the way home.

In the kitchen, where Memaw had glasses of tea and milk ready, we unwrapped the greasy, square, 5-cent burgers and began to smile at each other as we dug in!

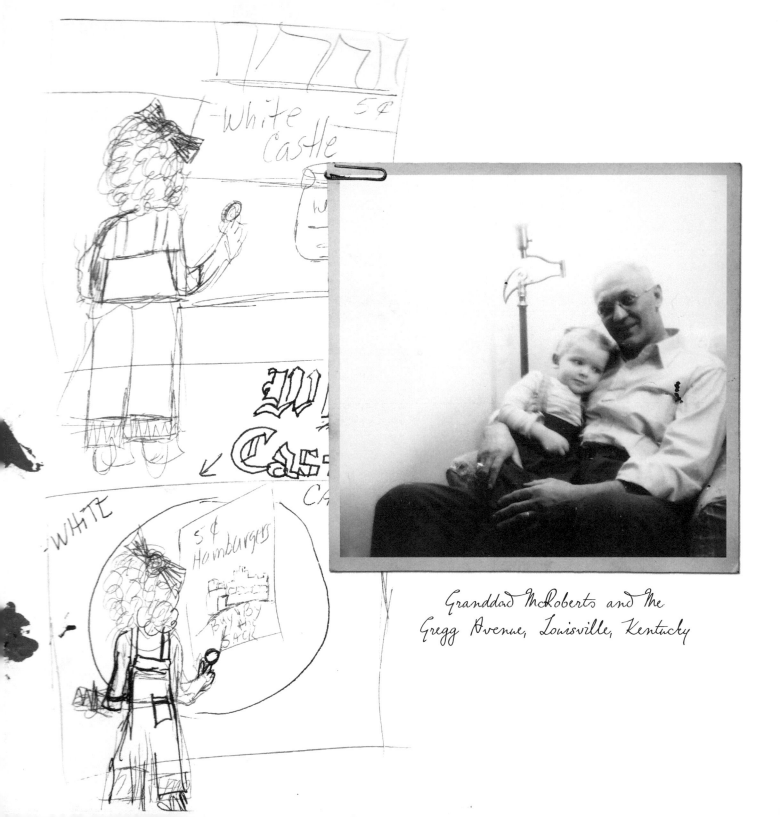

White Castle

5¢

CASTLE

WHITE

5¢ Hamburgers

BUY 'EM BY THE SACK

Granddad McRoberts and Me
Gregg Avenue, Louisville, Kentucky

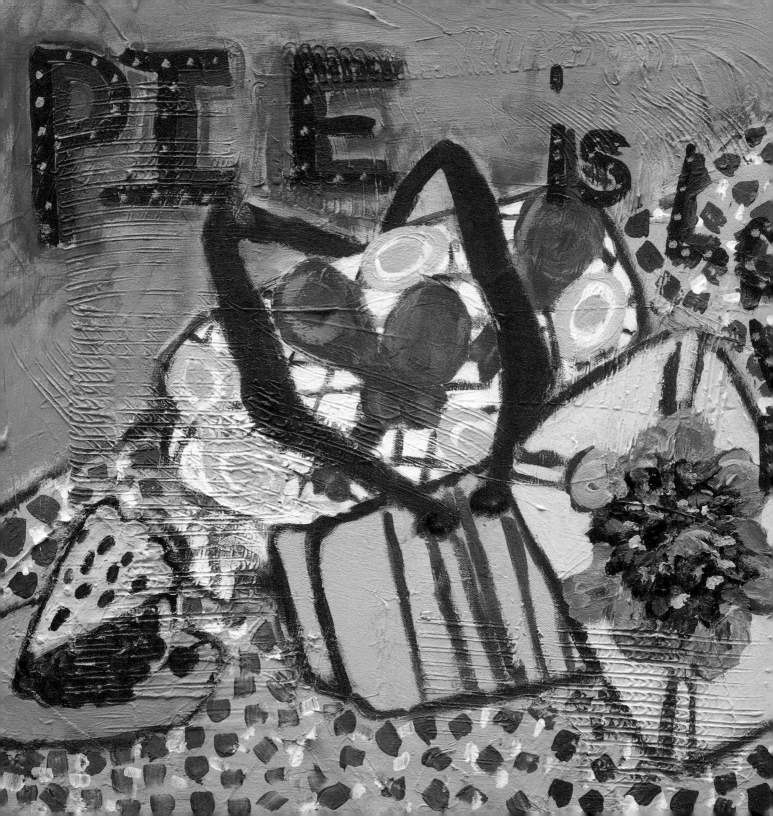

Magical Box Supper

It was a warm summer evening. Blankets were spread under trees, picnic tables were set with wild flowers. The table cloths were white with overlays of fabric covered with cherries, flowers, checks or dots. It was the early 1920's.

A box supper was beginning on the grounds of the two-room schoolhouse in Grand Tower, Illinois. My grandmother was one of the two young teachers at the school. She and her lady friends in the community made the food and packed the surprises in decorated boxes or baskets. Young men would buy one of the mystery boxes and join the cook for supper under the trees.

My sweet grandmother was engaged at the time to a young man from another town. It was to be just an evening with friends.

People talked, drank lemonade and soon the decorated boxes were placed on the long tables. My grandfather, young Floyd McRoberts, walked along the tables. He was drawn to a metal basket with ribbons and fresh violets on top. It was my grandmother's.

Later, Granddad McRoberts would say that after eating my grandmother's cherry pie, he knew he was going to marry her.

Her engagement was off. They were married and lived a long life together. I never found out what happened to the old fiancé. In fact, my mother told me this story not long ago. Memaw never did. I do know one thing for sure.

That must have been some cherry pie!

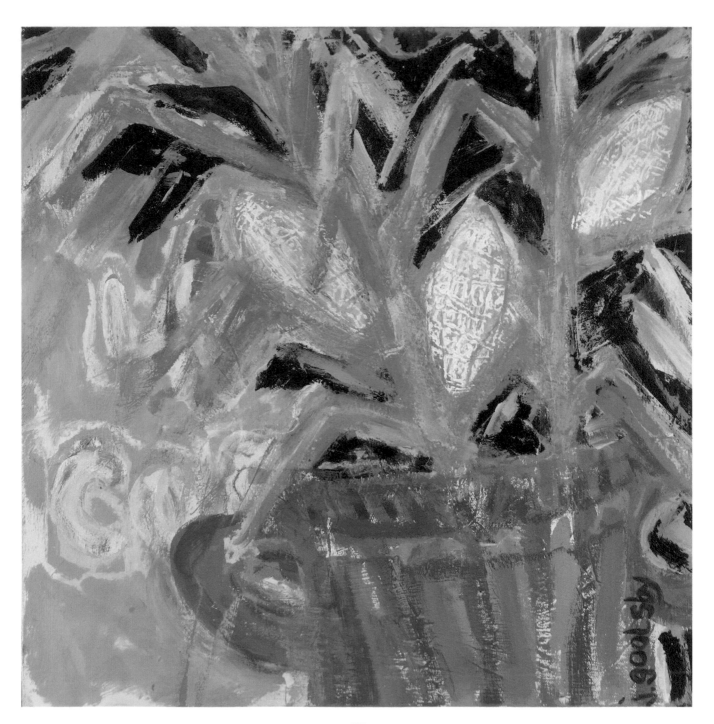

Corn In The Can

After World War II ended we were still living in my grandparents' house in Louisville, Kentucky. Mother and I were grateful for their love, nurtured not only by their support, but also by the delicious food they put on the table.

Memaw was a great cook. She had grown up in a large family where her job was to bake the bread and make the pies. She could make pie crust that melted in your mouth—really! I loved watching her in the kitchen. My mouth watered as her flour-dusted hands rolled out dough for cobbler or dumplings.

Granddad had planted a small garden behind the house to help provide for us. Along one side of the garden grew corn, tall and beautiful. I loved playing with my favorite doll in the shade that the plants cast on the ground. I liked hiding out there on hot summer days, partly to stay cool, but also to watch as the ears slowly ripened.

When the corn was finally ripe, I helped Granddad pick the warm green ears and place them in a metal bucket. Then we sat on stools under the maple tree and pulled off the husks and the silk, cleaning them down to the perfect yellow kernels. We put the clean ears in a bowl and headed toward the house.

Memaw was in the kitchen, her hair pinned up in a twist at the back of her head, her apron on. A huge pot of boiling water steamed on the stove, waiting for the corn. I liked to stand on a stool in the kitchen and watch her ease the ears into the pot one at a time until they were covered with the rolling water. She put the lid on the pot and we waited.

The table was set. Salt and pepper shakers shaped like Scottie dogs, one white, one black and best of all, butter, were brought to the table. The corn was the last dish to come through the kitchen door. Memaw brought in the orange platter piled so high with corn, you couldn't see the hand painted blue

flowers underneath. Corn-on-the-cob, soft and sweet, was my favorite vegetable. I could never get enough. I could have eaten it every night.

"Don't eat just corn, Judith Ann. Eat some peas."
"But I love corn-on-the-cob the best!"

I know that was true when one evening I disappeared. No one could find me.

Granddad opened the screen door at the back of the kitchen and stepped out. He called my name as he walked around the house and yard. He found me at the side of the garage, standing next to the trash can, chewing away on a big ear of left-over corn I had plucked straight from the can.

Gives new meaning to the phrase, *can of corn*, doesn't it?

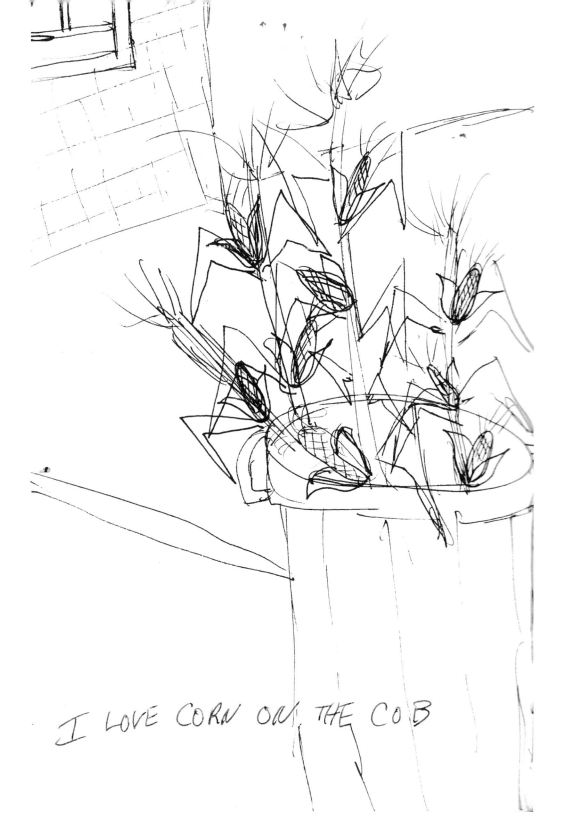

I LOVE CORN ON THE COB

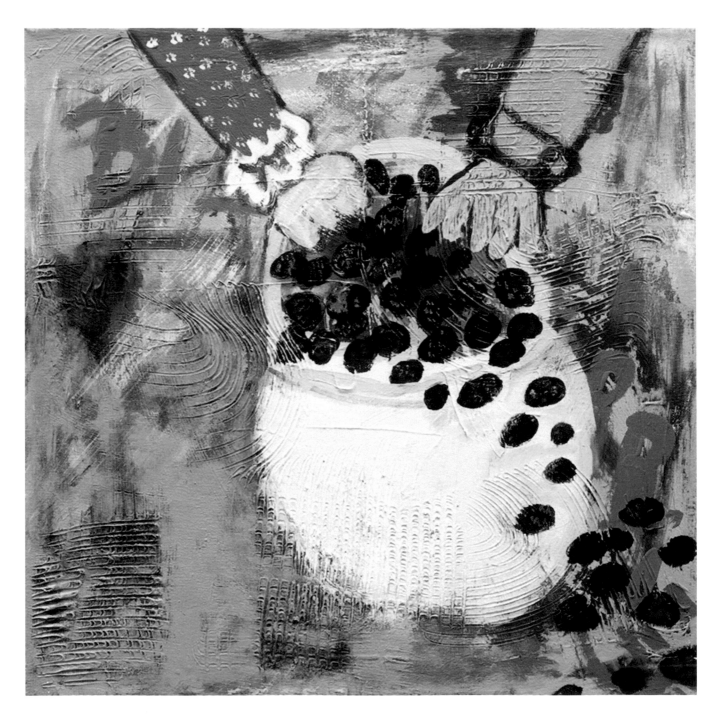

Blackberry Pickin'

A wooden wheelbarrow and a metal pail were all the tools needed to pick blackberries. Well, that and a great-grandfather willing to push the wheelbarrow with me in it.

Great Grandfather and Great Grandmother Whitlock's white frame house was just off a small dirt road in Cisne, Illinois. On the other side of the road were the railroad tracks where the freight trains lumbered along until they passed the edge of town and could speed up.

Great Grandmother had raised a family of six children and was a wonderful cook.

On summer visits to Cisne, Great-Granddad would get the wheelbarrow from the barn and I would climb in. Sometimes my cousin Johnny was visiting and both of us would fit our legs and our small metal buckets between the wooden sides. Grandfather would hang his large bucket on the hand grips and push us out of the yard.

Many of the dirt roads around the farm were lined with tangled vines full of blackberries growing wild. Stopping along the road and climbing over rock walls, we picked huge berries and dropped them in the buckets. Watching out for thorns that covered the vines and swatting horse flies away kept us busy and happy.

Once our buckets were filled with the dark purple fruit and our overalls were covered in dust, we climbed back into the wheelbarrow to head back to the farm.

I liked to stop and pick a handful of flowers for Grandmother. They were most likely weeds, but they had flowers on them.

The trick to picking blackberries was to actually get back to the house with berries in the bucket. I think I failed that test most of the time since the sweet warm berries were just too tempting.

Fortunately Grandfather's bucket was full to overflowing so we always had enough for cobbler. Thank goodness.

Sunday Supper

The screen door slammed behind Great-Grandmother as she came into the back yard from the kitchen, carrying a meat cleaver in her right hand. She had a determined look on her face. I had been standing on the back steps but stepped aside quickly when she came out the door. That cleaver looked ominous to a young girl.

Great-Grandmother placed it on an old wooden table, which leaned against the back of the house to the right of the kitchen door. The table was worn smooth in spots from years of use. She then headed to the log pile and gathered several pieces of wood, which she piled under the grate in the fire pit. She lit a fire, then filled a large cast iron pot with water and set it to boiling.

Next, she lifted the leather strap on the wire gate to the chicken coop, stepped through, and quietly closed the gate behind her. As she headed for a plump bird, the others squawked and fled to the top of the coop or ran along the fence, escaping Great-Grandmother for another day.

She quickly grabbed the chicken and with one swift wringing motion she broke its neck. I was horrified.

"It's the best way, Judi," she said. "They don't feel a thing."

Great-Grandmother deftly dunked the bird into the pot of boiling water up to its limp neck, moving it up and down quickly to loosen the feathers. Then she pulled it from the pot and tossed it onto the table. I can still smell the odor of the wet feathers that piled up on the table as she plucked the steaming corpse. It was not a pleasant smell.

Ah, the cleaver. I had almost forgotten. Before I knew it, she had hacked the poor bird into pieces. They were just the right size to fit into the iron skillet that was heating the Crisco on the wood stove in the kitchen.

You might think that learning how Sunday supper got to the table would keep me from loving Great-Grandmother's delicious crispy fried chicken. Nope, it was always too good to pass up.

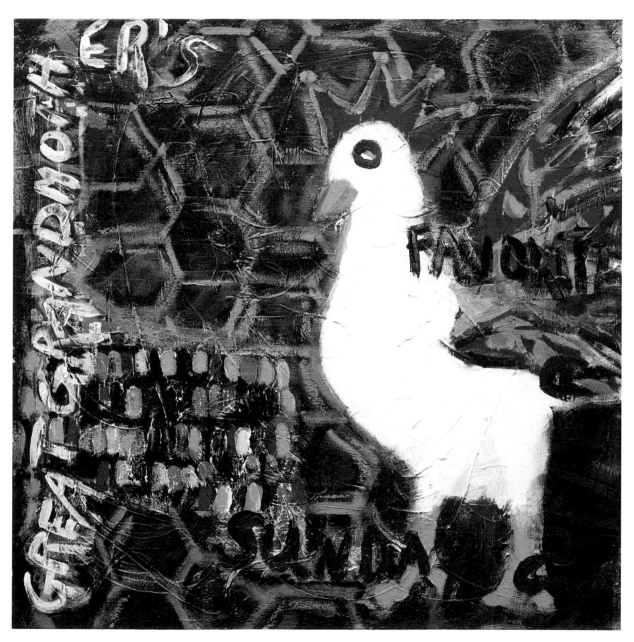

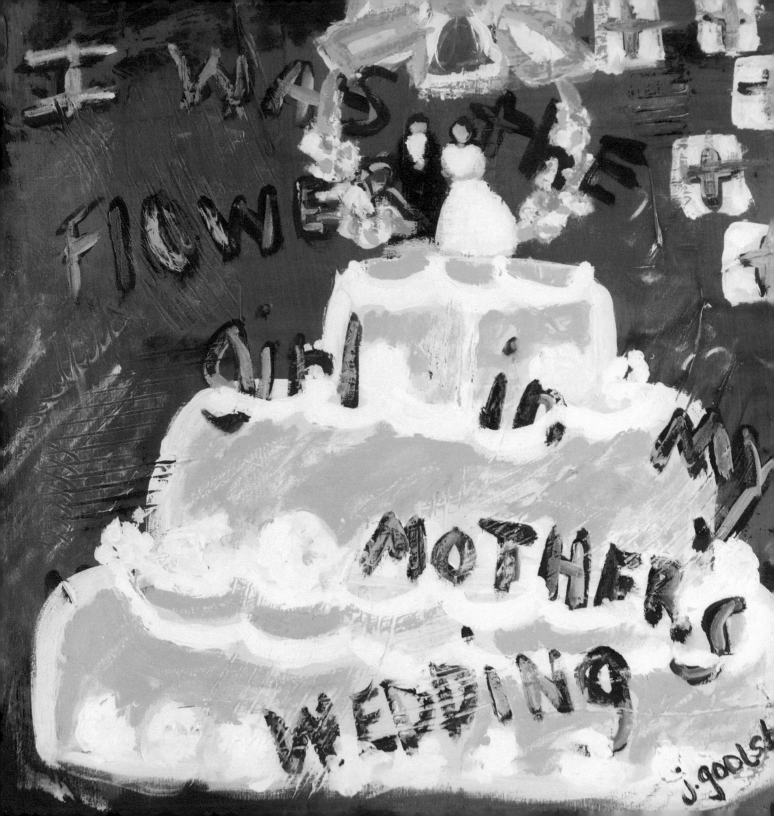

I Was The Flower Girl In My Mother's Wedding

Change is difficult.

My mother, a widow, was now becoming a bride. I had been at the center of my mother's world since my father's death three years before. Now, at the age of four, I would have a new father.

When I started this painting, I put on layer after layer of paint and hosed it off with a garden hose. I added and hosed off more paint and more colors, over and over. I couldn't find the right background.

I tried to figure out the right color under all those layers. I added marks, scratches, texture, and more color. I exposed bits and pieces of the ice blue color of my mother's satin wedding dress. The dress was simple, smooth as ice to the touch. But not this painting!

Oh, sure, I got to wear a long dress, carry a basket covered in ribbon and drop pink rose petals on the white aisle runner in front of my mother. But that's only a part of the story.

Eventually I decided to keep the red, orange, and fuchsia in the background and get rid of the pale pink and white. I painted the cake a cream color. Then I tucked the text into the icing. As some of the letters tumbled off the canvas I wondered how I really felt about this change in my life.

I remember a wedding cake with a plaster-of-Paris bride and groom on top—my mother and new father stuck under a tiny arch of artificial flowers.

After the wedding, the usual photograph was taken of me with my mother and new father in a car. They were going on their honeymoon. I looked shocked, realizing that I would have to get out of the car and go with my grandparents.

Later, as my parents drove away from the church, I knew my life would never be the same.

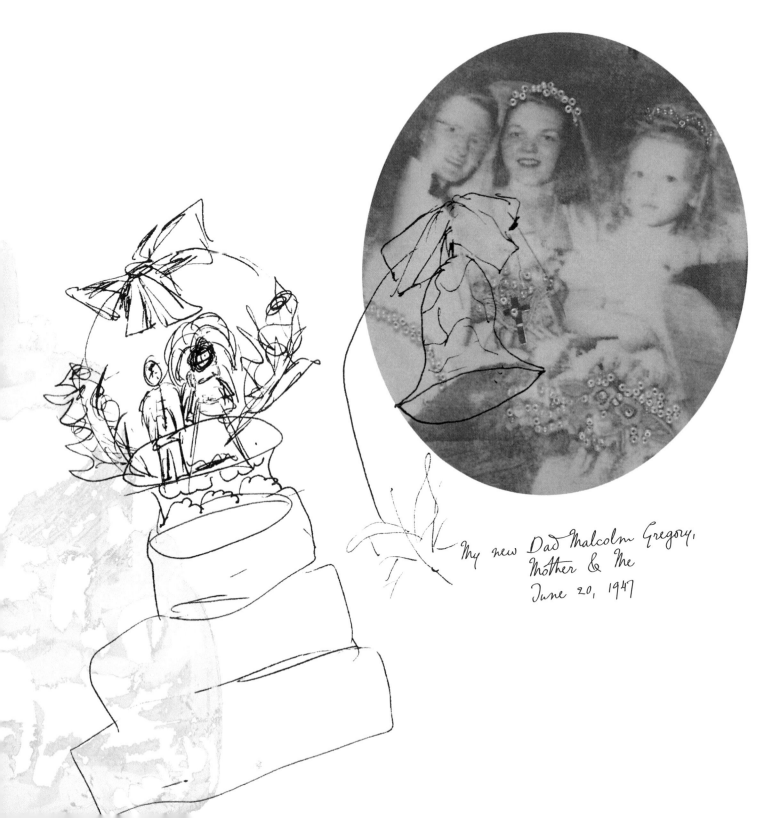

My new Dad Malcolm Gregory,
Mother & Me
June 20, 1947

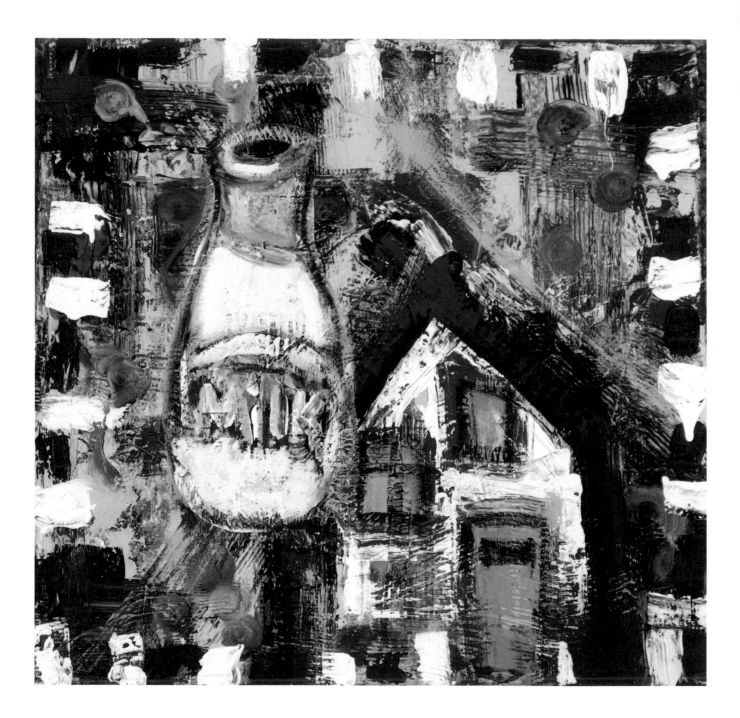

The Milkman Cometh

Before the sun came up, in winter cold or summer heat, the white truck passed through our neighborhood. Except for some tinkling or the occasional clanking of glass against metal, the truck was as quiet as a cat, creeping along on four wheels instead of paws.

At each house, the truck paused and a tall door slid open sideways, revealing the driver on a tall seat. He wore a white uniform with pressed pants and a starched shirt, a bow tie, and a white hat.

From the opening in the side of the truck, the milkman picked up the bottles for each house and placed them in his well-worn, metal carrier. Quietly walking up the sidewalk or driveway, through gates and hedges, he brought his creamy cold offerings to each family on our block.

The milkman set the bottles of cream and milk on the porch steps, or the landing of our house. He collected the empty glass bottles we left for him, placed them carefully back in his carrier, and carried them back to his truck.

Every morning, when we came downstairs to breakfast, we found the full milk bottles with paper tops waiting for us just outside the screen door. Like magic, they had come from the dairy to our house while we slept. I ran my finger over the droplets of moisture forming on the outside of the bottles in summer, and the icy, frost-like drops in winter.

Because the milkman came, we had fresh milk once again.

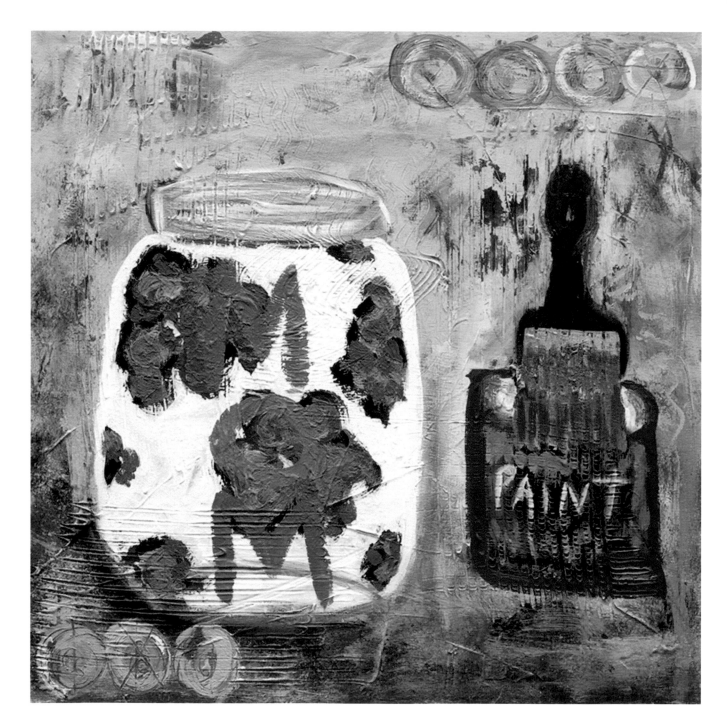

Most Expensive Cookie Jar Ever

I love refrigerator art. My daughter's refrigerator is covered with children's art celebrating Christmas, Mother's Day, Father's Day, Valentine's Day, and Easter. Most of the colorful pieces have a small face peering out from an opening in the painted surface. The sweet faces and round cheeks, or a missing tooth, would make anyone smile, especially my daughter. I can see almost a whole year of family celebrations in the children's art.

Mothers must have something built into their DNA to love their children's art and school projects.

Sometimes, though, they have to bite their tongues. My mother was a classic example. More than once she demonstrated grace under pressure.

We did not have much money, but Mother managed well. When I was in Kindergarten, I had six dresses. Five dresses for school (one for each day of the week) and one dress for Sunday. My mother washed, starched, and ironed them every week. I still remember the smell of the starch. It was a steamy, clean smell that gradually faded as the dresses dried.

One day, our teacher told us to bring a large glass jar with a metal lid to school. It was for a "secret project." I brought a jar that was tall and squared off on the edges. Mother also gave me a large shirt of my dad's. It made a good paint shirt, once I rolled up the sleeves that nearly swallowed my arms.

I had a week to paint the jar. It would take another week to dry before I could wrap it up and take it home to my mother for a Mother's Day present.

For five days I painted with thick enamel paint. Every day I went home with paint on my dress. Five days, five dresses, paint blobs on each dress. Yes, they were all ruined.

When the day came for Mother to open her gift, I could barely hold in my excitement. She gently peeled away the wrapping paper and looked at the colorful flowers and the word Mom on the cookie jar. She hugged me and told me she loved it.

That cookie jar, always full, sat on the yellow Formica counter in our kitchen for years. Did my mother think about the ruined dresses every time she looked at it? If it was hard for her to be happy and thankful for my special, very expensive gift, she never let me know.

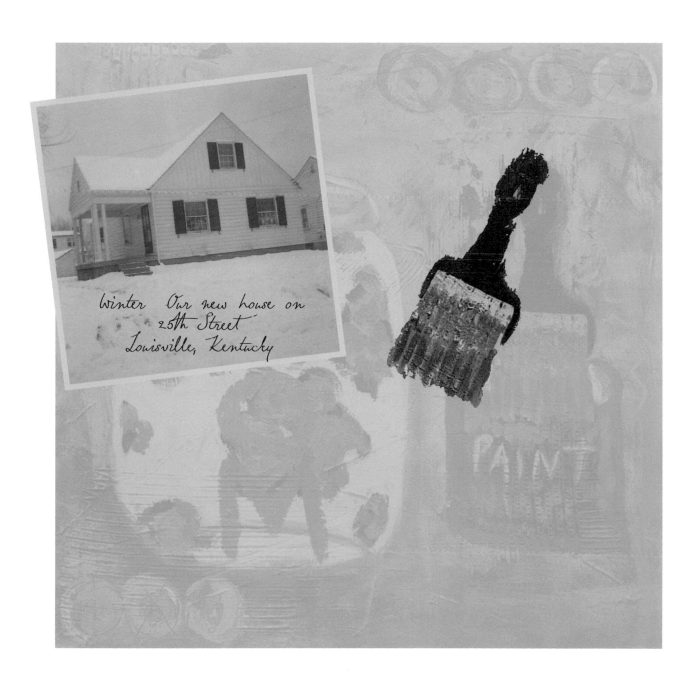

Winter Our new house on
25th Street
Louisville, Kentucky

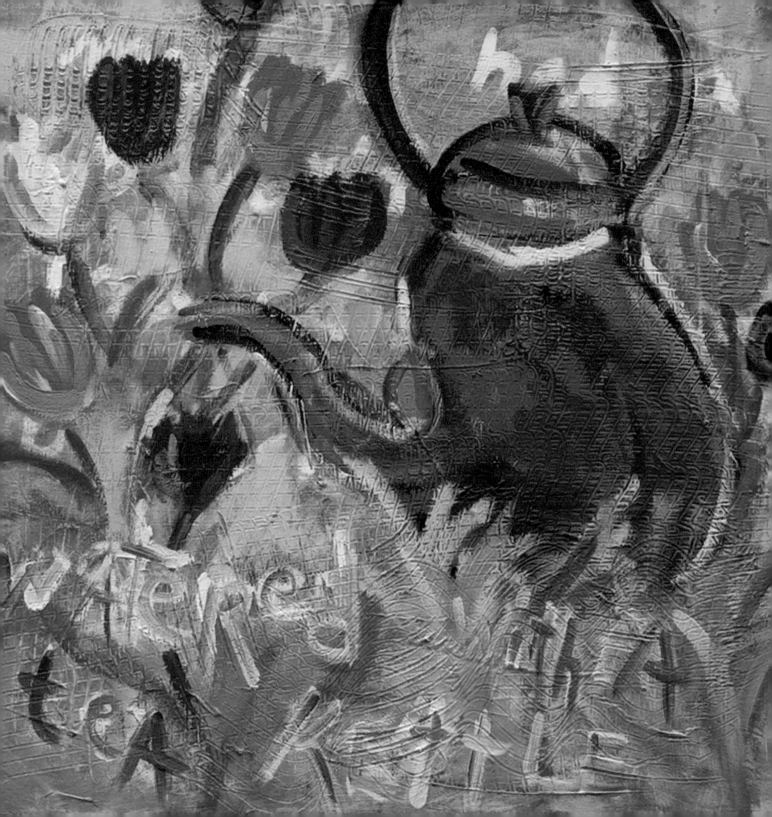

She Watered With A Tea Kettle

I was in elementary school and we lived about one block from my mother's parents. Wherever they lived, they always had beautiful gardens full of flowers.

They had lots of roses. Some were antique, some tea roses and some hybrid. I remember the Peace roses the most. They would grow as large as a dessert plate, really! I always loved the roses and flowers that smelled the strongest. Some of the Peace roses were cream colored on the outside and the inner petals were a little yellow and a little rosy colored. They smelled like a bottle of soft perfume.

"She Watered With A Tea Kettle"

Grandmother always shared her flowers with friends, family, and especially the church for Sunday services. She let me help her cut and trim the flowers and put them in jugs of water.

Many people walking or driving by would stop and ask how she grew such beautiful flowers. She would say that she just loved flowers.

Her neighbor had watched my grandmother tending her flowers for many years and one day she told her she knew why she had such wonderful flowers and gardens. The secret was that my grandmother watered her flowers with an old tea kettle.

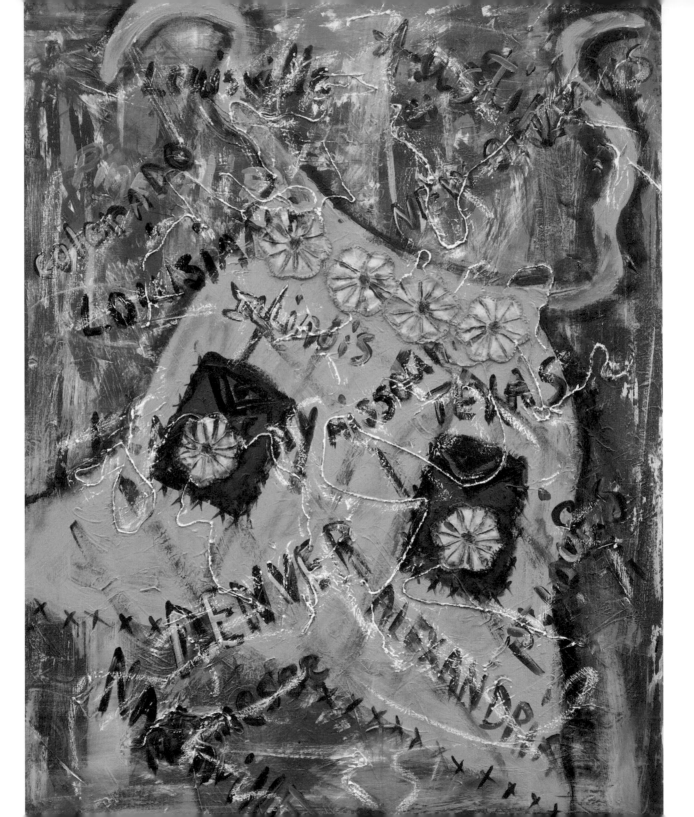

Apron Strings

I started this painting, *Apron Strings*, one day when I was rummaging through a bin in my studio. My hands pulled out an apron.

It was worn on the edges. It had flowers on the pockets that were long since faded. Above the right pocket, the fabric was almost worn through from my grandmother's hand putting things in and pulling things out. When I think back it was probably a tissue, a Smith Brothers cough drop, or a stick of Juicy Fruit gum for me. She always had something in her apron pockets just in case.

I adored my grandmothers, all of them. One lived just a block away, another in Cajun country in Louisiana, and Great Grandmother in Cisne, a tiny town in Illinois.

Women wore aprons then. It was just part of who they were and it was how I always thought of them. I felt tied to them.

My father's death had left empty spaces for Mother and me. Many of those empty places were filled in by women in aprons.

My life has been filled with change so I painted in the places, the towns and cities, where we had lived and spent time with family. Some are on top of the painting and some are tucked under the apron.

Aprons were worn to protect clothes from messes and to have a place to wipe the hands of the women in my life.

As I painted, I could see how aprons and their strings held me and brought rich meaning to me as a little girl.

I cut the faded flowers from the apron front and attached them to the painting. Then I added strings to the surface to tie the loose ends of the story together.

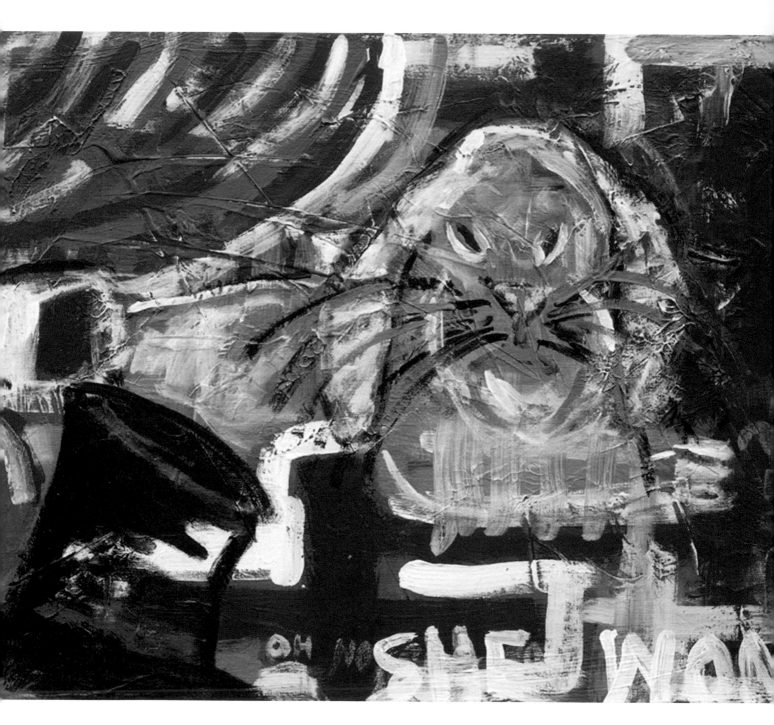

Magic Show

I thought about doing this painting many times whenever I heard the words magic or magician.

We lived within walking distance of the elementary school as well as the high school that had a large auditorium.

Mother bought tickets to see a magician perform there. We dressed up in our best church clothes and walked to the auditorium and had great seats up close on the third row.

The show was colorful and fast paced. Toward the end of the show the magician had the traditional trick of pulling a rabbit out of a hat. The top hat was black, of course, and the rabbit was white, furry and in sharp contrast to the magician's black cape lined in red satin.

After the trick and the applause died down, he announced that when he called out the word *go*, the first person to shout *Abracadabra* could take the rabbit home.

You see what's coming of course? Maybe I should explain the problem Mother had. We were not allowed to have pets except fish. My new dad was not a pet lover since they made messes!

The magician called out "1, 2, 3, Go!" and with one leap, I jumped to my feet and yelled "Abracadabra" at the top of my lungs, and the rabbit was mine!

He called me up on stage to receive my new pet. What could my mother say in front of all those people? So we headed home with a white ball of fur snuggled in my arms.

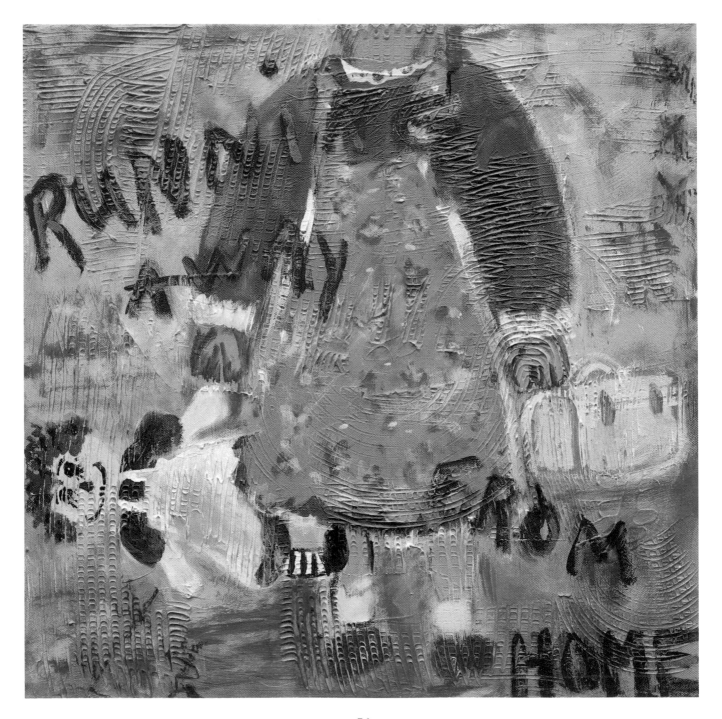

54

Running Away From Home

"Here, let me help you pack. I will miss you," my mother said.

I was six years old and running away from home. I'm not sure what had gotten me to this point, but I was leaving. I probably had threatened to run away before; this time, my wise mother was not arguing with me about it.

"How would you feel if I ran away from home?" she quietly asked. "I think you would miss me."

Before I knew it, she had turned, headed to the door, opened it, and disappeared. SHE was running away!

I was stunned. Left standing alone with my doll and suitcase in hand, the impact of my threat to leave was rapidly beginning to fade. At that moment I realized that running away was a bad idea. Then, I made an even worse decision.

Going down to the kitchen, I looked out the screen door and saw my mother coming around the corner of the neighbor's white frame house. I suppose the devil made me reach out and lock the door. Click!

The rest of the story turned out as you might expect.

I did eventually open the door and let my exasperated mother in.
I did have to pick a switch from the huge weeping willow tree next door.
I did give it to my mother. . . .

My running away days were over!

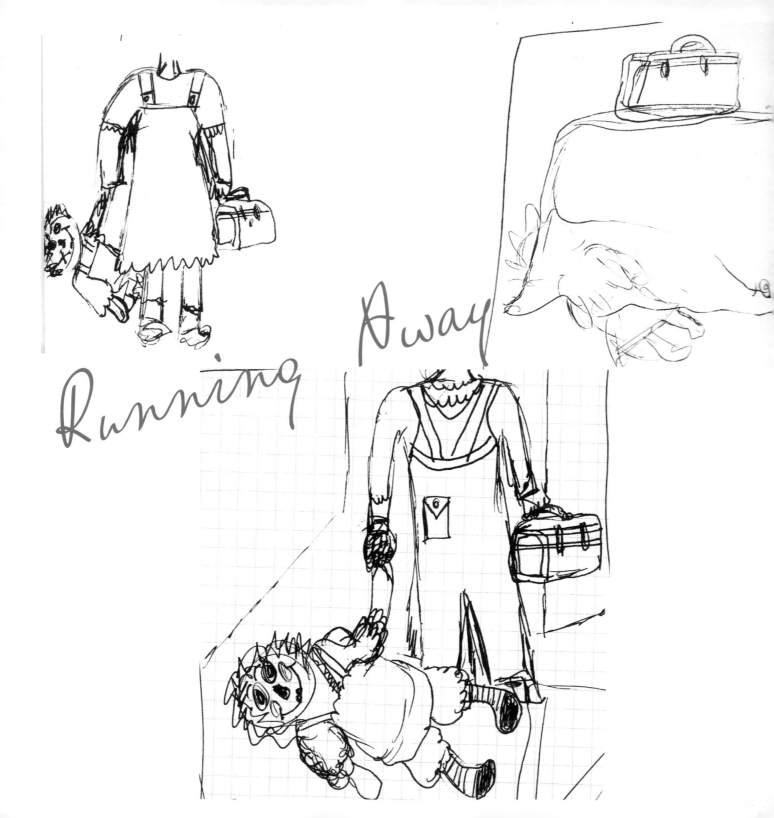

Running Away

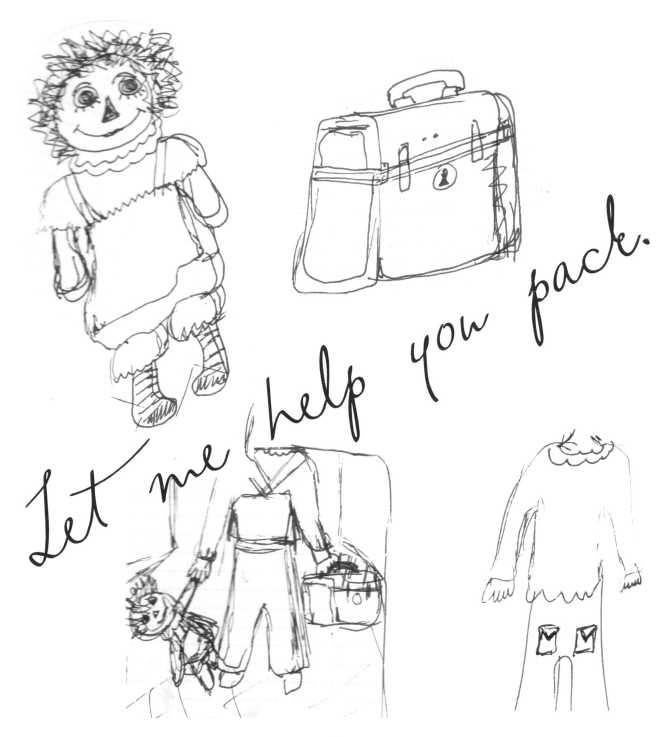

Let me help you pack.

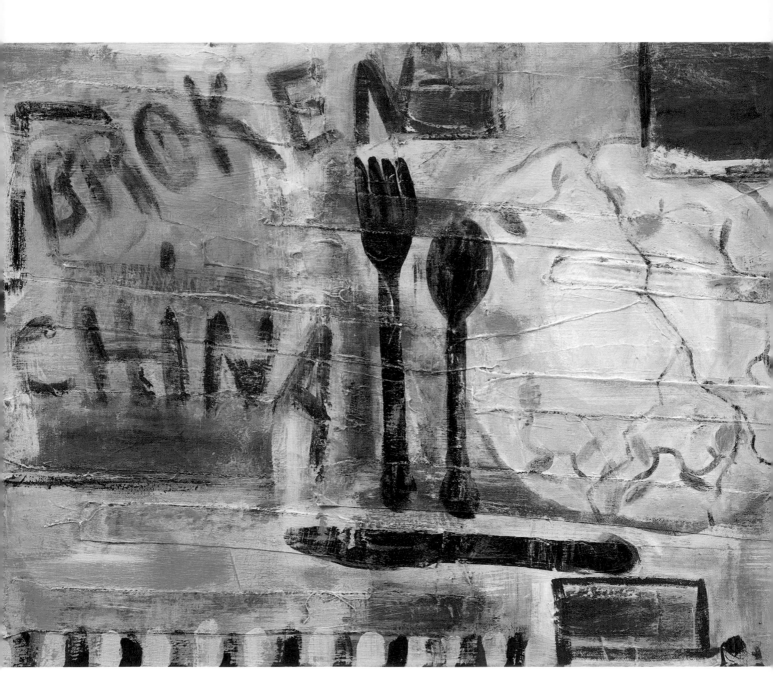

The Diner

I wonder who invented Formica. Do you remember all the colors, formed and molded into almost endless shapes and sizes of tables, chairs and counter tops? I also wonder what those diners along the highway would have done for furnishings if Formica hadn't been invented.

It was just such a diner sitting back from the two-lane road that looked like a good place for lunch. The front porch was raised off the dirt with about six wooden steps that could have used a new coat of paint. A wooden railing held in the front walls of the building that were bursting with metal and wood advertising signs. Coca Cola, R.C. Cola, Blackberry Cobbler Today and Blue Plate Specials, to name only a few of the signs that hung on the walls.

Granddad and Memaw were taking me with them to visit relatives in Illinois.

We got out of the car and crunched across the gravel drive and up the steps. We opened the screen door and found that we were the only people inside. A waitress came out of the kitchen and said we could sit wherever we wanted.

She quickly brought us water, silverware and a hand written menu on lined school paper before disappearing through the swinging doors to the kitchen.

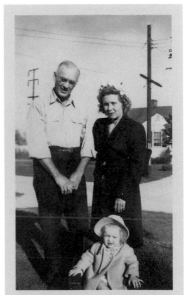

About a minute later there were shouts from the kitchen. The cook and the waitress were yelling so loudly we stopped reading the menus and looked up at each other. Suddenly plates and dishes started hitting the kitchen doors and breaking into pieces.

Memaw looked at Granddad. He stood up, took me by the hand and we all headed for the screen door.

After reaching the car and climbing in, Granddad started the engine and looked over into the back seat at me. He smiled and then burst into laughter.

Granddad, Memaw, and Judi

As we drove away my grandmother said, "Floyd, that's not funny".

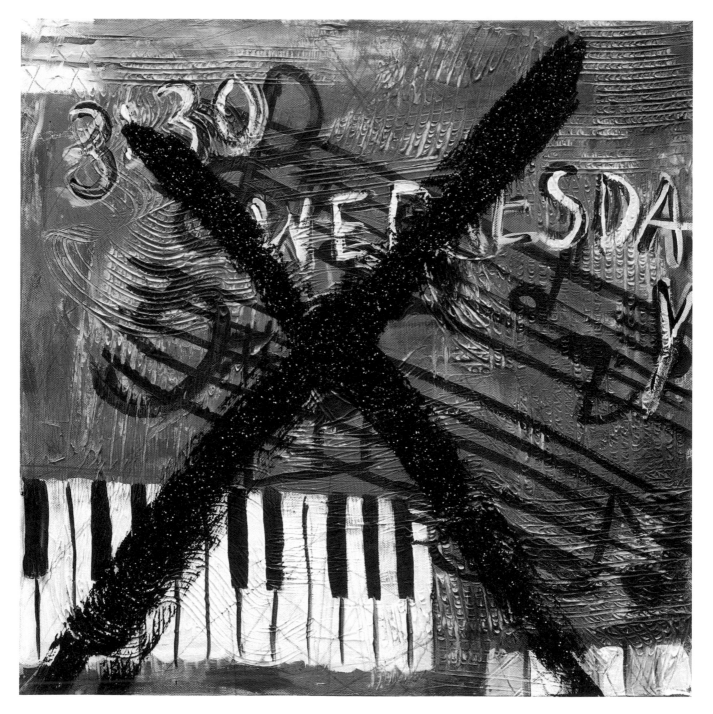

Kicking Rocks

It's 1952. It's Wednesday at 3:30 in the afternoon.
It's EVERY Wednesday at 3:30 in the afternoon.
I dreaded Wednesdays!

My hair is brushed, my blouse is ironed, the pleats in my skirt are neatly pressed, my white socks and saddle oxfords are on my feet, and I'm kicking rocks.

Walking along the uneven gray sidewalk with the pressure of my piano books under my arm, I look for little white rocks in the brown gravel that cars have thrown up on the walkway. The white ones seem to go farther when the toes of my black-and-white shoes catch them just right. I try one foot and then the other, always hoping something new might happen as the pebbles take flight. Working on various techniques as I walk along, I pray that time will gobble me up and transport me somewhere else.

The inevitable always happens. I reach Miss Martin's front walk. There are no more rocks to kick, no more ways to stall, just the long walk up to the door, one slow step at a time.

I would much rather be on her blue porch swing swaying in the breeze, free from scales and chords.

When the door opens, I see the black "thing" waiting for me. I climb onto the cushioned bench, feet dangling, and it begins: Wednesday at 3:30, my piano lessons.

One hour later I'm down the steps onto the sidewalk again. No more kicking rocks. Now I'm running and skipping, my heart is light. I have a whole week before next Wednesday at 3:30!

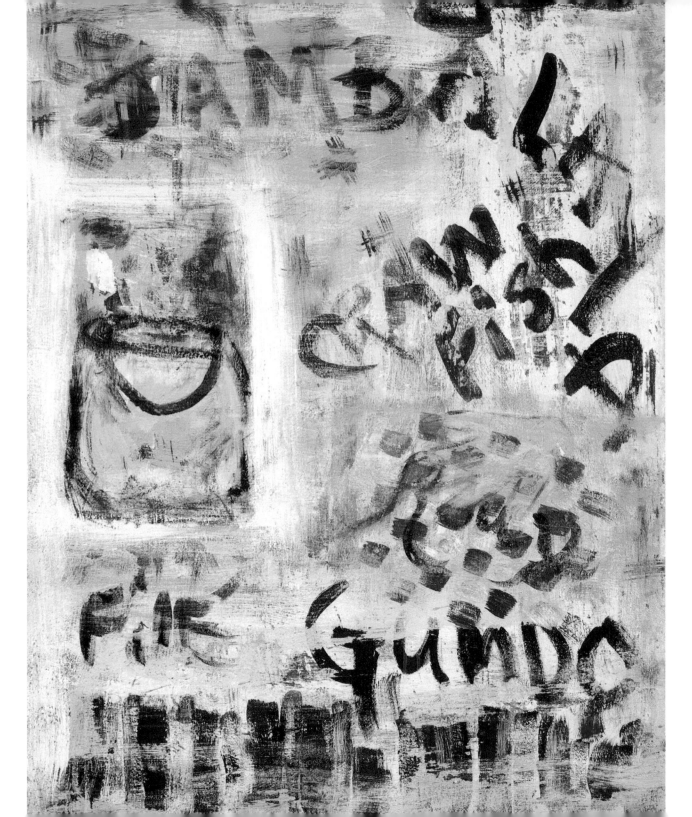

Paintin' Cajun

As an artist new to painting, I took workshops with well-known painters with very different styles. I kept asking myself where I was in those paintings? Finally deciding to find my own voice, my own style, I signed up for two days one-on-one with abstract painter Dan McBride.

Armed with canvases, brushes and paint, I began packing the car. He asked me to bring examples of my work, books with images I liked, and artists' work I was drawn to.

As I leaned some of my work against the walls of the studio it became clear. I could easily sort the paintings by the instructors I had studied with. Oh, sure, my brush strokes were there, but I had a collection of work that was recognizable in other artists' styles.

I was a really good mimic!

I chose a couple paintings, photos and books I liked, and stacked them in the trunk. At the last minute I noticed some textile pieces I had done. Each layered square was a story from my childhood I had stitched with hundreds of stitches. I put them in the car too.

After a couple hours going through my work, photos, books, I pulled out the stitched stories.

Dan looked at them as I relayed the meaning in the squares.

"Judi, this is it. This is what you should paint. This is where your voice is, in the stories and the colors that are here."

I grabbed the brushes and paint and started putting paint on the canvas with abandon. I tried quickly hosing off some colors and then painting more on. I kept going, painting and hosing until I liked the layers.

As I looked at the cloth square about my Memaw's kitchen in Louisiana, I stopped thinking so much and started painting the memories of jambalaya, gumbo and dirty rice on the stove. Remembering the warm spicy smell of shrimp, crabs, and crawfish.

I found myself and my voice in that painting.

Four Generations
Memaw McRoberts, Mother,
Great Grandmother Whitlock, Me

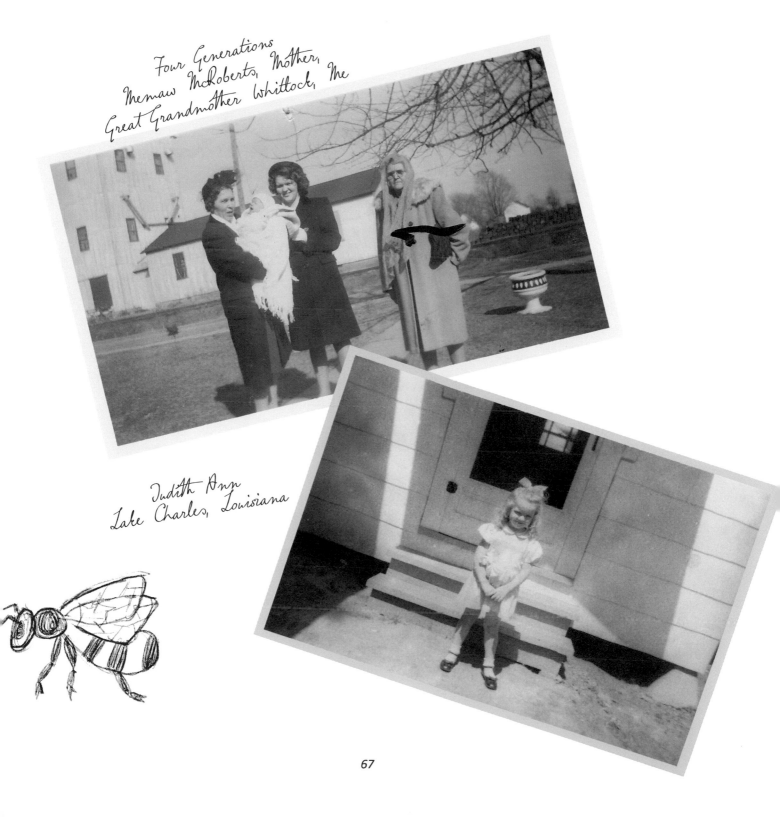

Judith Ann
Lake Charles, Louisiana

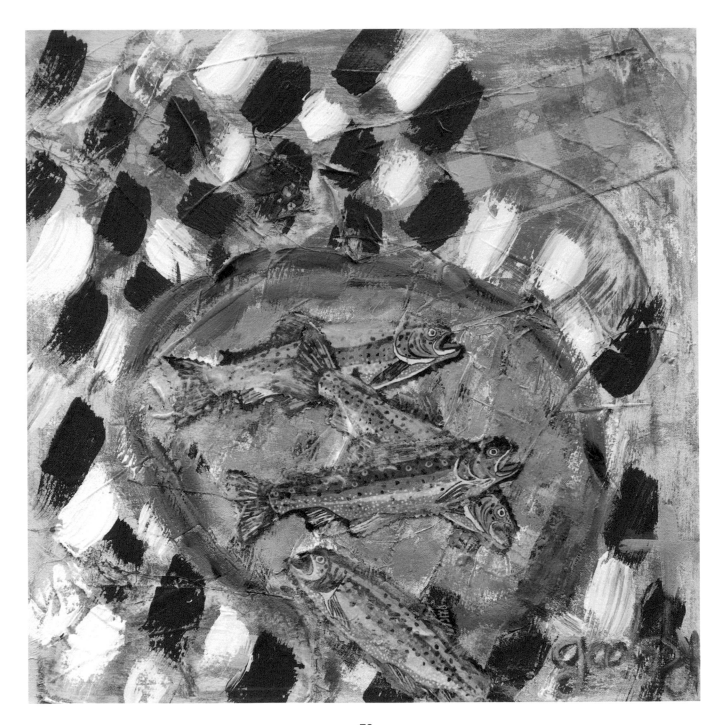

Bayou Picnic

Second only to catching the fish with my Memaw East was cooking them. I had never had grilled fish until those summers in Louisiana.

The grill was a big oil drum that Granddad East laid on its side and cut in half. He put a handle on the top half and a rack inside with a hole on both ends for air.

He loved making things out of something that started out as something else and his oil drum grills were perfect.

Being a great cook was only one of Memaw's many talents. She made beautiful brightly colored quilts that we used for many things.

Whether we picnicked in the back yard or on those quilts down on the bayou, there was nothing better than catching fish and cooking them on that grill except for homemade peach ice cream!

Giggin'

The fireflies were sparking, the moon and stars were bright. Still, we needed flashlights to see the surface of the dark water.

My uncles were taking my cousin Johnny and I frog gigging. They lived in Cisne, Illinois, close to my great grandparents and more than a handful of great aunts and uncles.

The best place to get frogs was the marsh around the oil wells in the fields close to town. Whenever my grandparents brought me from Kentucky to visit our relatives in Illinois, I knew we were getting close when I could see, and smell, the oil fields.

That night, when we got to the marsh, we put on our rubber boots and started sloshing around the murky water. Johnny and I shone our flashlights on the surface of the water and the frogs began leaping frantically toward the light beams. My uncles were ready. They used gigs, long sticks with forked ends, to spear the frogs. Uncle Pink was the best one at this task. He would spear a frog and quickly drop it into the bucket and close the lid.

It was a crazy scene with the lights shining, frogs leaping in all directions, boots splashing water everywhere, and our squeals and laughter.

The next night was the real treat as we gathered around the table in Great Aunt Virginia's kitchen. I loved that kitchen. It was warm and there was always something on the stove that smelled wonderful. I especially liked the black phone on the wall. It had a crank that you turned when you wanted to call the operator and have her connect you to someone on the party line.

We always had frog legs, battered and fried in an iron skillet (the tendons cut first to keep them from contracting and leaping out of the pan); cornbread; white gravy; fresh green beans; and tomatoes from the garden. I didn't like tomatoes, so I passed on those, but I never skipped dessert.

There was always pie. Yum!

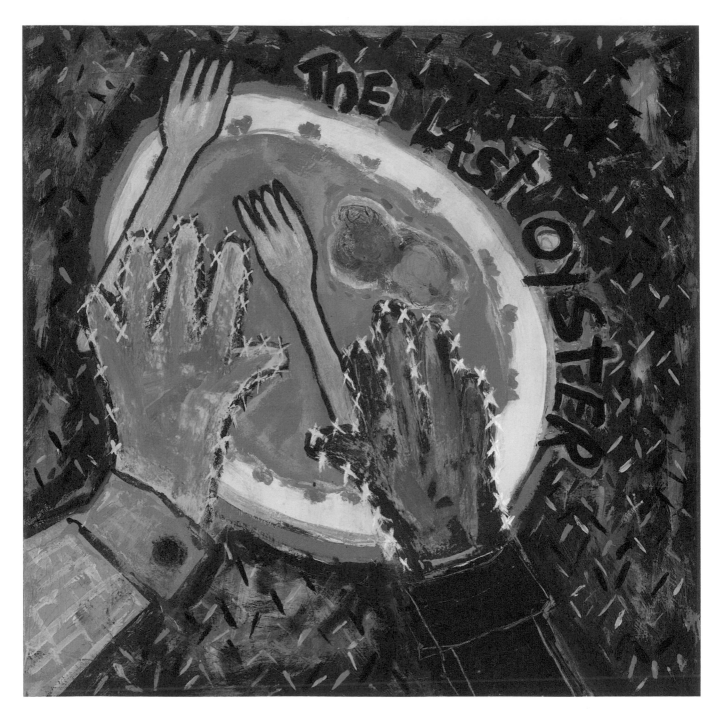

The Last Oyster

It was alone on the platter, the center of attention of three pairs of eyes around the red vinyl kitchen table. The contest was about to begin.

Wait. Let me back up.

Mother was a good cook, and her fried oysters were delicious. Because post-war budgets were tight, oysters were a special treat. Granddad McRoberts and my dad were oyster-eating kings. Jim, our friend and boarder, loved them, too.

Mother would begin by shucking the oysters, cleaning them, and making an egg batter. She dipped the slimy (as they seemed to me) little circles into the batter, and then into a bowl of fresh cornmeal, over and over until there was a thick coating of batter hiding the oysters inside. She fried them until they were golden.

One night, as our family was enjoying the oysters, rolling dark clouds began forming outside. Dusk was coming early, it seemed. It was warm in the kitchen. Rain began to pelt the windows and roof while everyone talked and laughed. The pile of oysters dwindled until there were only a few. Finally, a lone oyster lay on the platter.

We all knew the men wanted it, but they waited, drinking tea and eying the last one.

Suddenly, lightning and thunder shook the air, and the lights flickered and went out. All was quiet for a long moment. Then the light bulb over the table flickered, illuminating an empty platter in the middle of the table. Two hands holding forks futilely stabbed the edges of the platter.

As all eyes turned toward him, Granddad smiled. The last oyster resting on his plate.

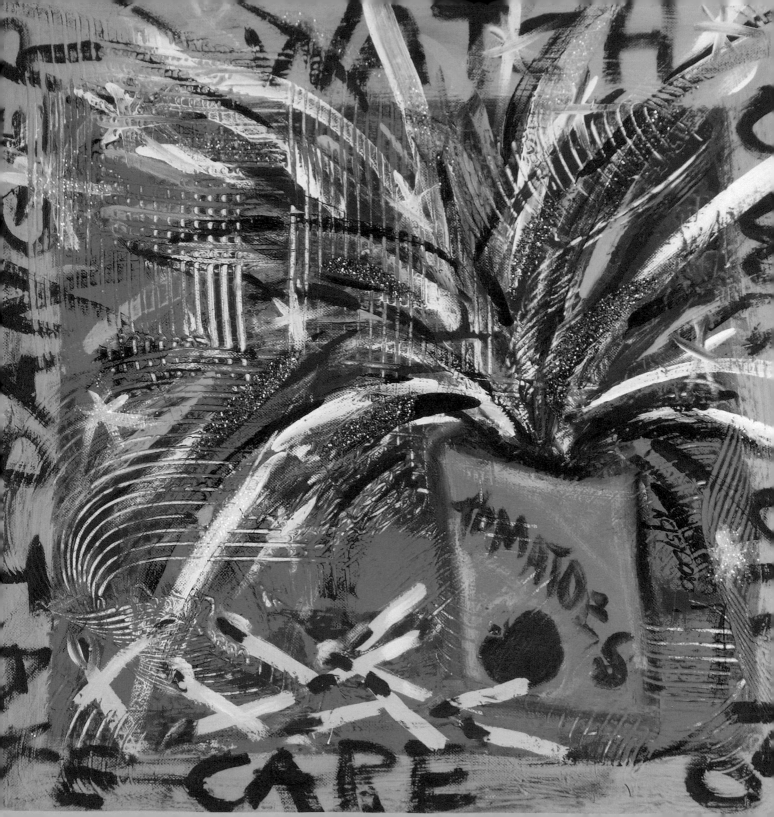

Fireworks In A Tomato Can

Can you remember what you were and weren't allowed to do growing up? When visiting my relatives and spending summers in Louisiana, I know there were lots of things I did that I could not have done at home. There was a freedom there in Cajun country that is hard to explain. Of course it was the 1950s.

There was one Fourth of July when I was in Louisiana visiting my Aunt Nadine and Uncle Johnny. I was 12 years old and my wild child cousin John Curtis was always coming up with what I thought were brilliant ideas.

This time we were waiting for the hamburgers and corn on the cob to cook. He had a bag full of firecrackers (something I wasn't allowed to have). He thought that bigger is always better, and that louder was the best.

He had lit a few single firecrackers and thrown them into the air with no significant noise other than some pops.

Next came the brilliant idea. Why not put a firecracker in an empty can, light it and see what happens. We found an empty tomato can in the trash bin. After looking at it, he reasoned that a single firecracker was not going to do much. Why not a can full of them?

Johnny grabbed a handful of the fiery noisemakers and stuffed them into the tomato can. The match was lit and dropped in among the tightly compressed sticks of powder. Voila!

As I hit the ground face down the can was catapulted skyward with fire and fumes gushing out as it flew past my head. The noise was spectacular enough to send all the grown ups bursting through the screen door and breathing their own brand of fire!

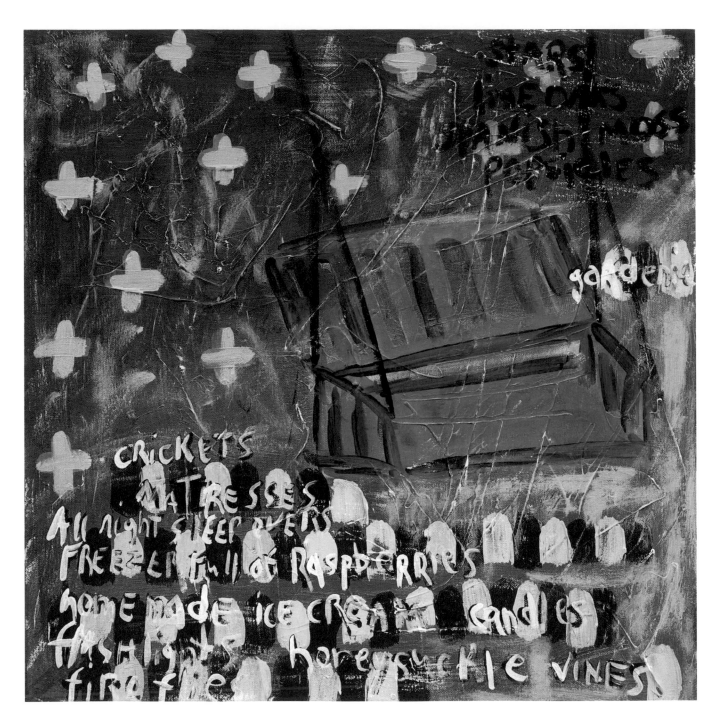

stars
fireflies
spanish moss
popsicles

gardenia

CRICKETS
MATRESSES
All night sleep overs
FREEZER full of Raspberries
homemade icecream candles
flashlight honeysuckle vines
fireflies

Porch Stories

Dusk is falling slowly after a steamy Louisiana day. Mosquitoes begin coming out for their nightly meal and buzz in our ears. We swat them away as we run to the house, looking like little windmills. We take refuge on the wrap-around screened porch under the Spanish moss drooping from the branches of the live oak trees.

The floor of the porch is painted white, worn smooth under the table and chairs and at one corner under the double swing with the faded blue checked cushions.

Some of my favorite childhood memories are of the summers we visited my grandparents in Louisiana and the many hours we spent on that porch. My aunts and cousins and I played Monopoly and cards nonstop for days.

Through the open windows of Memaw's kitchen wafted mouth-watering aromas of gumbo, crabs, dirty rice, and bread fresh from the oven. The sweet smell of cherry or blackberry cobbler filled the air. In the garden, gardenia bushes were loaded with blossoms, and honeysuckle grew wild on the fences. The aromas from the kitchen mixed with the scent of flowers in the garden were imprinted on me when I was a child, and I can still remember them.

We slept on mattresses under the fan blades when no air was moving indoors. The huge chest freezer, a staple of houses in the South, hummed softly at the back of the porch. It was filled with fish from my days in the boat with Memaw East. Stacked in one corner of the freezer were wax-coated boxes of fresh raspberries, blackberries, peaches, and cherries picked along country roads.

On the porch we read books on rainy, stormy afternoons, laughed at each other's jokes until our sides ached, painted bright pink polish on our fingers and toes, and braided each other's hair.

If that porch could talk, it would fill pages with stories of little girls' secrets and tales of fishing, boyfriends and games that were won and lost.

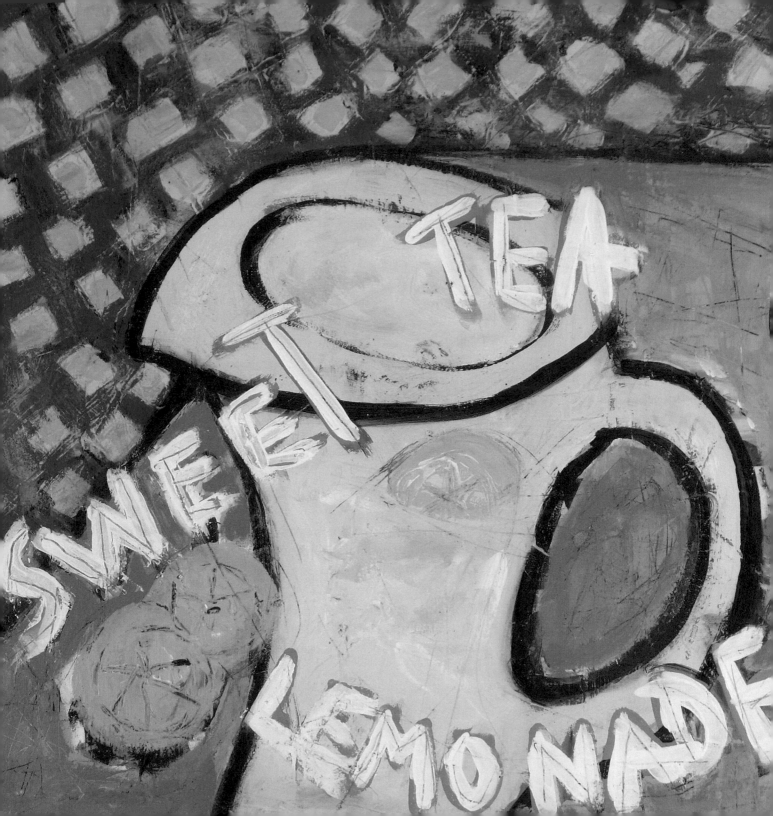

Sweet Tea And Lemonade

Spanish moss hangs low and thick from giant oaks that form tall umbrellas over the lawn and the screened-in porch.

It's hot and steamy. The humid air is almost palpable.

Paint is peeling from the porch rails and window frames of my grandparents' white frame Victorian house. The ceiling fans click as they turn, the paddles stirring the moisture-laden air heavy with the scent of gardenia and honeysuckle.

I'm spending the summer of 1950 with my father's family in Louisiana, close to the bayous and cypress swamps.

My young aunts and I wear sundresses and sandals, our hair pulled up in ribbons to keep it off our damp necks. We try to move as little as possible. There's plenty of time to laze in a rocker on the porch or in the swing reading Nancy Drew or making a move toward Boardwalk in the marathon game of Monopoly that goes on for days.

Pampaw's dog, Jughead, has retreated under the house at the corner of the porch. The house is up on stacks of bricks so he can easily find the cool shade. He also is moving as little as possible. Smart dog.

Survival that summer was definitely dependent on the endless supply of sweet tea and lemonade. The tall crystal pitchers on the faded pink table were kept full during the heat of the day. Next to the pitchers was a giant bucket of ice. Often there was a block of ice with an ice pick for splintering pieces off to put in our glasses, hold in a napkin, or let melt on our tongue.

We drank the sweet cold liquid in gulps, then sips. We ran the sides of the ice-filled glasses over our sweaty faces and necks. That was heavenly!

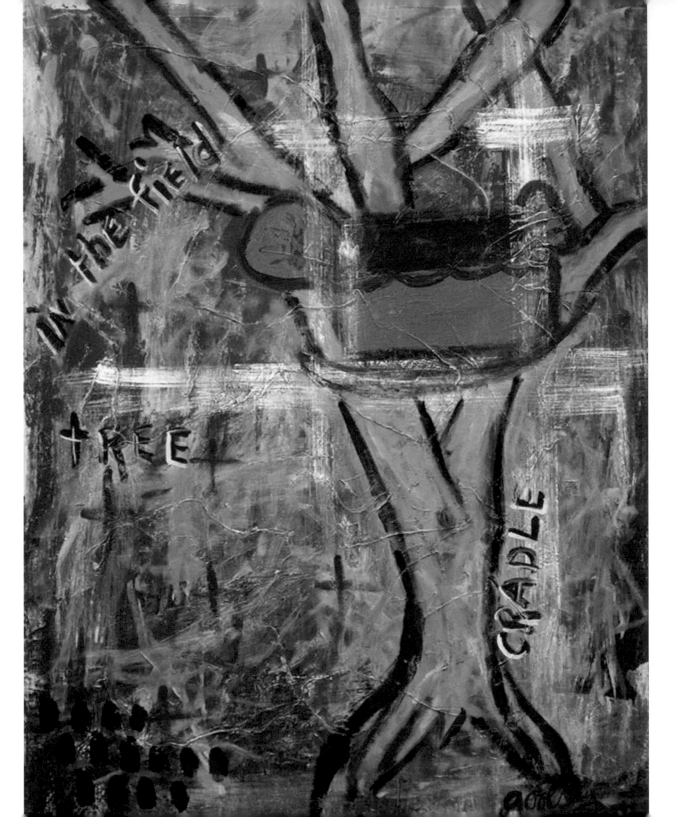

Whip Snake

If you say the word *go* to Judi, she will get that suitcase out and start packing her clothes before you have a chance to turn around.

As she stared out the window at the 1950 baby blue Studebaker, Mother was thinking how my three aunts, my uncle and I, were going to fit into that little car.

It didn't matter. We were determined to make it work.

Uncle Johnny was driving. Aunt Nadine was sitting in the front, her reddish hair tied up in a ribbon to keep it off her neck. Her glasses were slipping a little on her nose from the drops of sweat forming there. It was hot. Blistering hot.

Sue Sue and Patsy were in the back and all of my eight-year old body was literally wedged in between them. I remember thinking that Sue Sue and Patsy might grow up to be very tall since their legs were so long. Wearing short shorts made all our legs stick to the gray vinyl seats. Every time we moved or shifted our weight, there was a sucking sound of skin pulling itself away from the sticky surface.

Sue Sue had really dark curly hair down to her waist. I marveled how she had been able to grow it so long. I'm sure Mother would have made me cut my curly hair before it got that long.

Sue Sue was only four years older than I and Patsy was a year older than Sue Sue. They were the youngest of my father's sisters and I never really thought of them as my aunts, more like cousins.

Visiting relatives along the long drive from Kentucky to Louisiana was the cheapest way to travel and my Aunt Nadine was an expert at saving money. My Pampaw had said she could squeeze the poop from the buffalo on a nickel. I remember laughing out loud at that one.

My father, Aubrey, was her older brother who had been killed along the coast of Okinawa in the war in the Pacific. They had been very close growing up in a large family and I guess that's why I was so special to Aunt Nadine.

Every trip with Aunt Nadine and Uncle Johnny, and there were many in the summers of my childhood, was an adventure. I never told my parents most of the details of those trips. Mother would have understood and appreciated the humor in most of it, but my stepfather wouldn't have. So this story was never told until years later and was never written down until now.

At that time, most roads were two-lane, no big interstates. It was hot in that Studebaker with no air conditioning. Even when we ate ice from a little cooler parked under my feet and drank lemonade, our hair was always plastered to our foreheads in ringlets.

There were the usual sights to see on the back roads going south from Kentucky through Tennessee and Mississippi before making it to Louisiana. We made up games to distract us from the heat and the trickle of perspiration down our backs. That's a gentile Southern term for sweat pouring off your body for hours on end.

Keeping a list of road kill was a way to pass the time. Mostly skunks and armadillos and occasionally a big snake making their ill timed way across the steaming asphalt always brought a shout from the rear seat.

But I was waiting for The Tree.

Somewhere along a seldom-traveled road in southern Mississippi lived The Tree.

A broken down fence partially overtaken by a thicket of vines and weeds ran along the shoulder of the road. It seemed to hold in what looked like miles of open fields. In the middle of the fields of thigh-high grass and wild onions stood The Tree.

Most of the year there were no leaves on the tree. In summer there were a few green spots here and there. The dark gnarly branches reached out in all directions like arms. They were bent and curved and tangled allowing only small glimpses of the sky between the limbs.

Held in the arms of the tree toward the top was a box. It was not an ordinary box but a small, child size casket.

I heard myself shouting, "there it is" as I wiggled up to see out the side window.

Uncle Johnny slowed the car and moved along the fence so we could all get a good look.

Tell me the story again Aunt Nadine!

"There was a child who belonged to a family who lived on the farm at the back of the field. No one knows why, but the child died. The parents couldn't bear to bury their child. The father built a casket and they placed the child inside and put the casket in The Tree where the child had played.

The Tree held the casket through winds and storms and never let it fall. Eventually the family passed away, the house fell down, and the crops died.

The Tree still held the casket.

Sometime after that, a man from a nearby town decided to climb the tree and see what was there. As he climbed the fence and stepped into the field, he noticed the tall grass begin moving in the distance. Suddenly, there it was!

A huge whip snake was rolling its body through the tall grass toward the intruder. He barely made it over the vine-tangled fence before the snake curled itself along the fence and moved back into the field, swaying the grass as it went.

The word spread about the snake that guarded the casket and no one has ever gone into the field again.

Nothing grows on the land except the tall grass that hides the snake, and The Tree is still alone in the field cradling the bones."

Uncle Johnny began pulling slowly back onto the pavement, looked over the seat at us and began laughing.

I just love my Aunt Nadine!

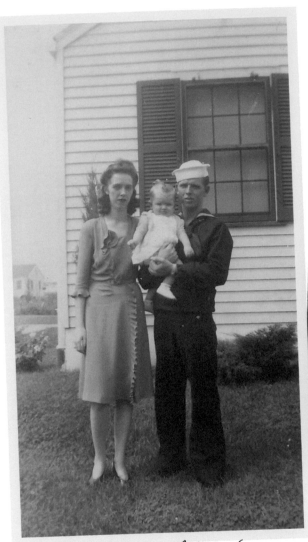

Aunt Nadine, Aubrey (my
Dad) and me

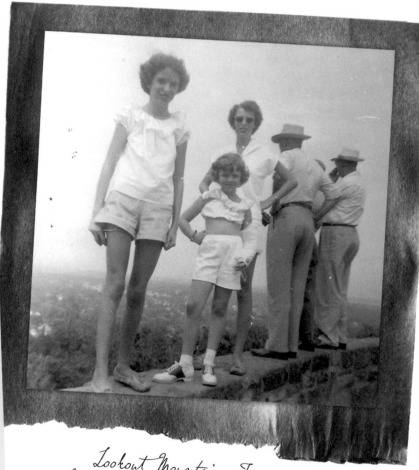

Lookout Mountain Tennessee
Aunt Sue Sue, Aunt Patsy, and Me
Road Trip to Louisiana

On Right: Road Trip, 14x14, Acrylic on canvas

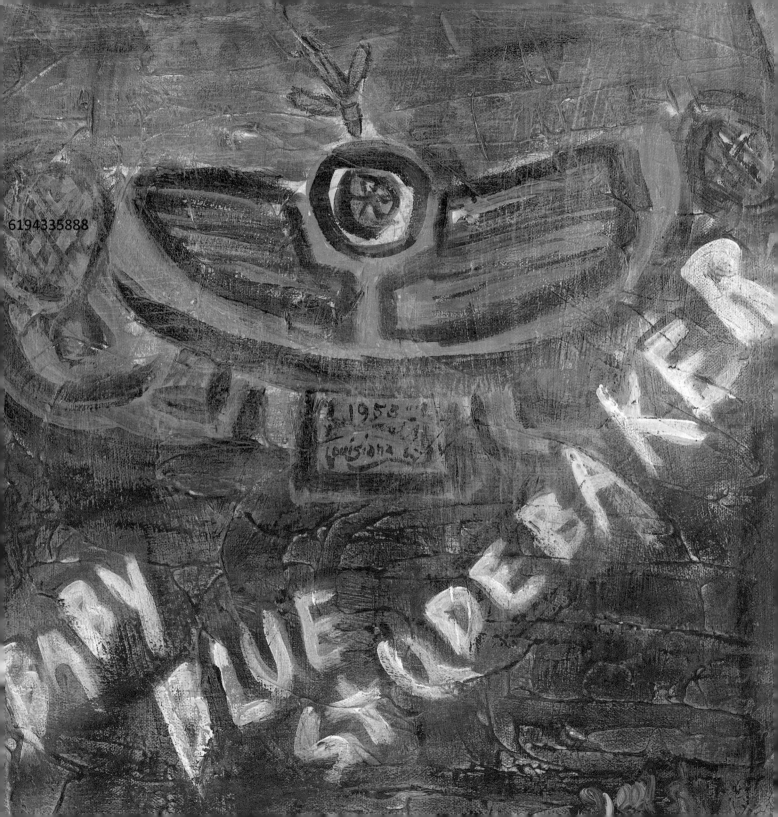

"The great thing about getting older is you don't lose all the other
ages you've been"
Madeline L'Engle

Aubrey's parents Leonard
and Minnie East's home
until 1942
Grand Tower, Illinois

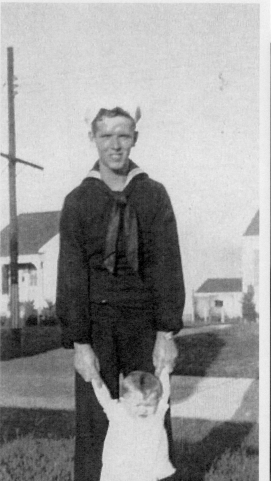

Aubrey & Judi

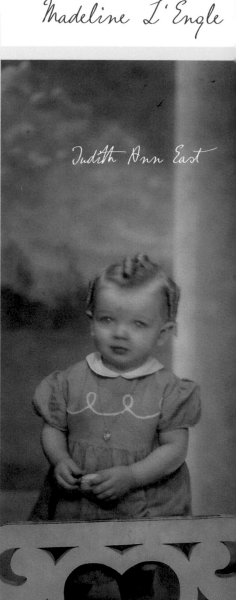

Judith Ann East

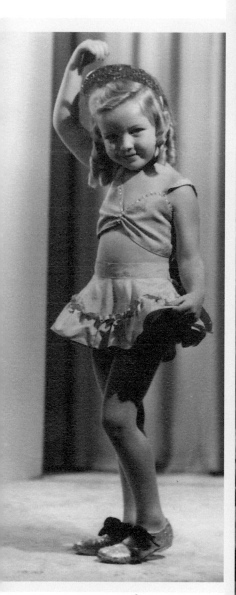

Tap Dance Recital
Judi age 4 1/2

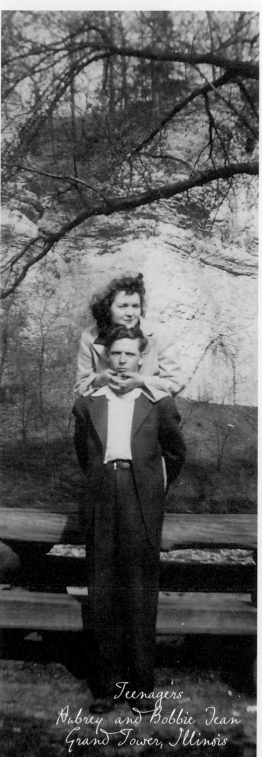

Teenagers
Aubrey and Bobbie Jean
Grand Tower, Illinois

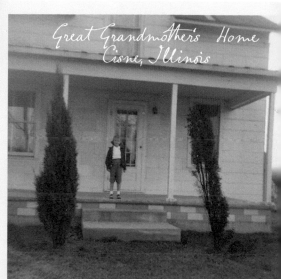

Great Grandmother's Home
Cisne, Illinois

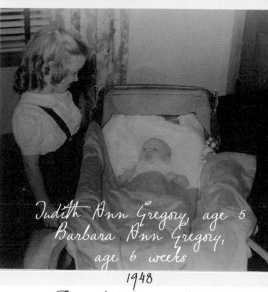

Judith Ann Gregory, age 5
Barbara Ann Gregory,
age 6 weeks
1948
They let me pick my
new sister's middle name.
What did they expect?

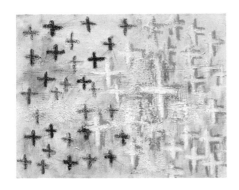

August 14, 1945
Acrylic on canvas, sand, oil
sticks, 22"x28"

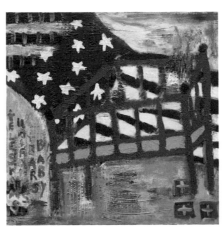

When Word Came
Acrylic on canvas, 20"x20"

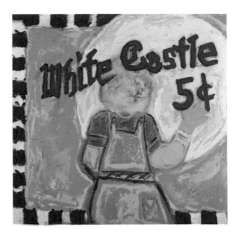

White Castle
Acrylic on canvas, 30"x30"

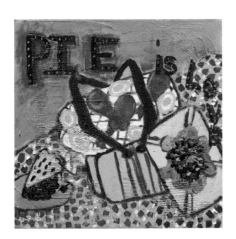

Magical Box Supper
Acrylic on canvas, fabric,
20"x20"

Corn In A Can
Acrylic on canvas 20"x20"

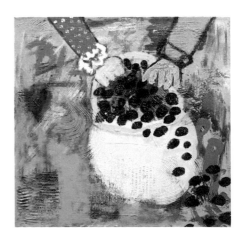

Blackberry Pickin'
Acrylic on canvas, 20"x20"

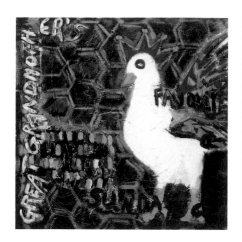

Sunday Supper
Acrylic on canvas, oil sticks,
20"x20"

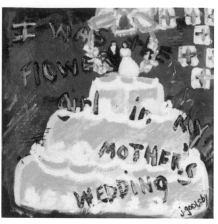

I Was The Flower Girl in
Mother's Wedding
Acrylic on canvas, 20"x20"

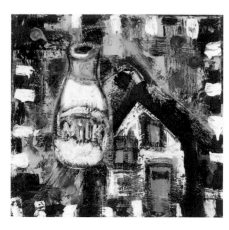

The Milkman Cometh
Acrylic on canvas, 20"x20"

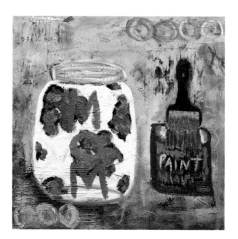

Most Expensive Cookie Jar Ever
Acrylic on canvas, 20"x20"

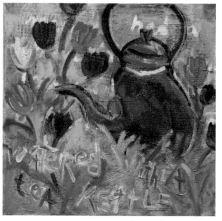

She Watered With A Tea Kettle
Acrylic on canvas, 20"x20"

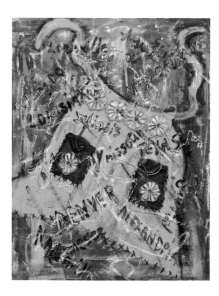

Apron Strings
Acrylic on canvas, fabric, string,
40"x30"

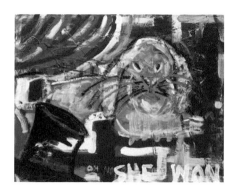

Magic Show
Acrylic on canvas, oil sticks,
16"x20"

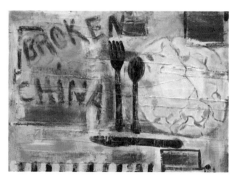

Running Away From Home
Acrylic on canvas, oil sticks,
20"x20"

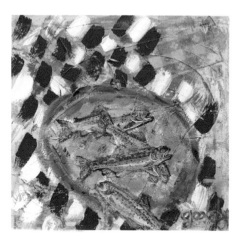

The Diner
Acrylic on canvas, fabric, oil
sticks, 18"x24"

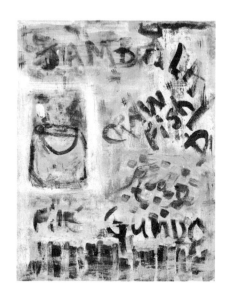

Cajun Cookin'
Acrylic on canvas, oil sticks,
40"x30"

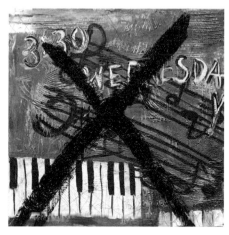

Kicking Rocks
Acrylic on canvas, synthetic mica,
20"x20"

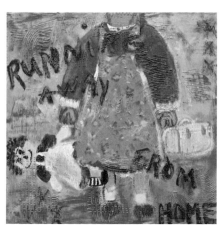

Bayou Picnic
Acrylic, fabric on canvas,
18"x18"

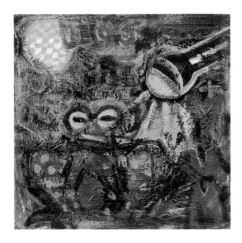

Giggin'
Acrylic, oil sticks on canvas,
20"x20"

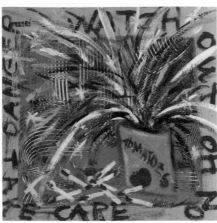

4th of July In A Tomato Can
Acrylic on canvas, synthetic
mica, 20"x20"

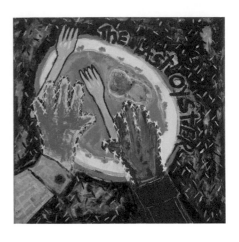

The Last Oyster
Acrylic on canvas, 20"x20"

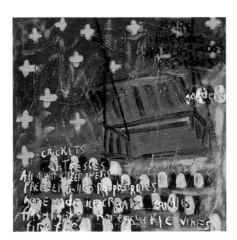

Porch Stories
Acrylic on canvas, 20"x20"

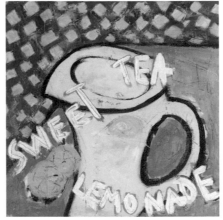

Sweet Tea And Lemonade
Acrylic on canvas, 20"x20"

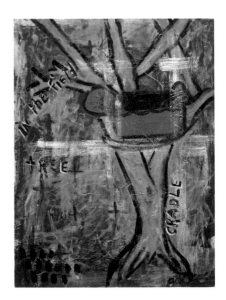

Whip Snake
Acrylic on canvas, oil sticks,
40"x30"

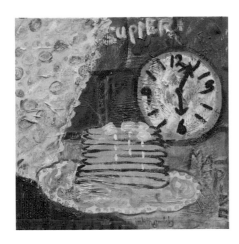

Pancakes for Supper
Acrylic on canvas, 20"x20"

The Blue Bottle Tree
Acrylic on canvas, 40"x30"

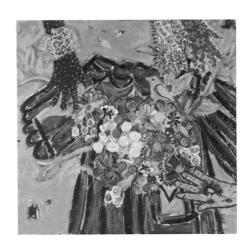

Four Generations
Acrylic on canvas, 30"x30"

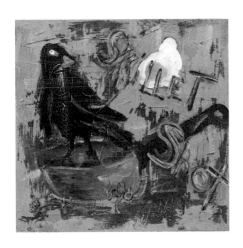

Skillet Shot
Acrylic on canvas, 18"x18"

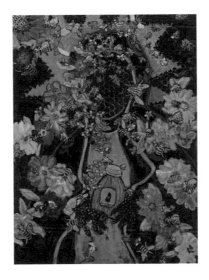

Black Madonna Honey
Acrylic, fabric, mica, on canvas,
48"x40"

Afterword

I began this book with a quote from William Faulkner.
I think it is fitting that I end it with another quote from the same
Southern author.

*"The past is not dead.
In fact, it isn't even the past."*

As long as there are memories to paint,
stories to tell or write down,
I think the past is as close as
your easel or mine.

judi goolsby

I have been under the spell of the South ever since I was born in Louisville, Kentucky in 1943. I was not, however, under the spell of being an artist when my 6th grade teacher crushed that possibility by telling me, "Judi, you don't paint people very well, so I don't think taking art is a good idea for you." I never took art after that.

During a high school trip to France, the works of Van Gogh, Monet, Matisse, and Degas rekindled my love of art.

Later, while studying elementary education in college, I had the good fortune to take a six-week course, Teaching Elementary School Art, with the head of the Art Department. I was inspired again.

As a first grade teacher, I had the freedom to integrate art and creativity into every subject I could. The children astonished and inspired me in ways I could never have imagined with their naive and totally fearless work.

Then in 2006, an artist friend encouraged me to paint. After taking workshops with several well-known artists for three years—Stephen Kilborn, Kim English, and Leigh Gusterson—I decided to take an abstract class from Santa Fe artist, Dan McBride. It was Dan who pushed me to recognize how my strongest voice as an artist rose out of childhood stories and images flavored by my Southern upbringing.

Now my layered, narrative paintings echo the spell of the South and the primitive art of the children who taught me, even as I was teaching them.

My favorite painting boots.
From the South to the West, boots are always a good idea don't you think?